THE WAY HOME

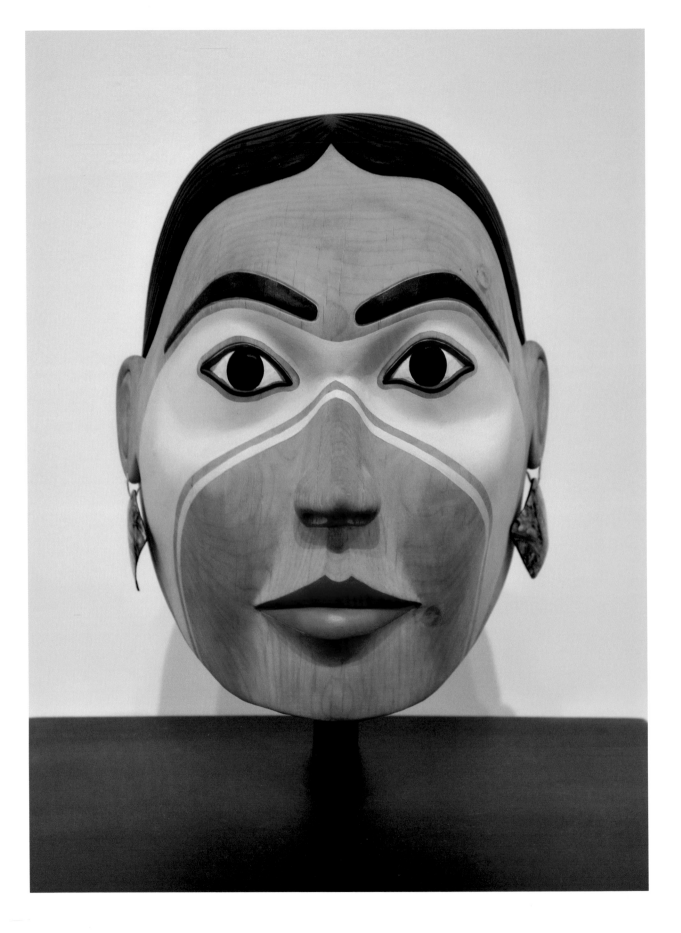

THE WAY HOME
DAVID A. NEEL

 a UBC Press imprint
Vancouver . Toronto

front cover and page ii

Ellen Neel, the First Woman Carver mask, 1990

alder wood, paint, and abalone shell,
16 × 11 × 6.5 in.

Portrait masks are an age-old tradition in Northwest Coast Indigenous culture. This one is a tribute to my grandmother, who is recognized as the first woman totem pole carver.

overleaf

Neel family members pose as a human totem pole, 1960. From bottom: Bob, Ted, Dave Senior, and Theo.

28 27 26 25 24 23 22 21 20 19 5 4 3 2 1

Printed in Canada on paper that is processed chlorine- and acid-free, with vegetable-based inks.

Cataloguing data is available from Library and Archives Canada.
ISBN 978-0-7748-9041-0 (softcover) / ISBN 978-0-7748-9042-7 (PDF)

Canada

UBC Press gratefully acknowledges the financial support for our publishing program of the Government of Canada (through the Canada Book Fund), the Canada Council for the Arts, and the British Columbia Arts Council.

Printed and bound in Canada by Friesens

Cover and interior design: Jessica Sullivan
Substantive editor: Merrie-Ellen Wilcox
Copy editor: Lesley Erickson
Proofreader: Judith Earnshaw

UBC Press
The University of British Columbia
2029 West Mall
Vancouver, BC V6T 1Z2
www.ubcpress.ca

THIS BOOK IS DEDICATED

TO THE WISE ELDERS,

KNOWLEDGEABLE PEOPLE,

AND KIND MENTORS

WHO HELPED ME TO FIND

MY WAY HOME.

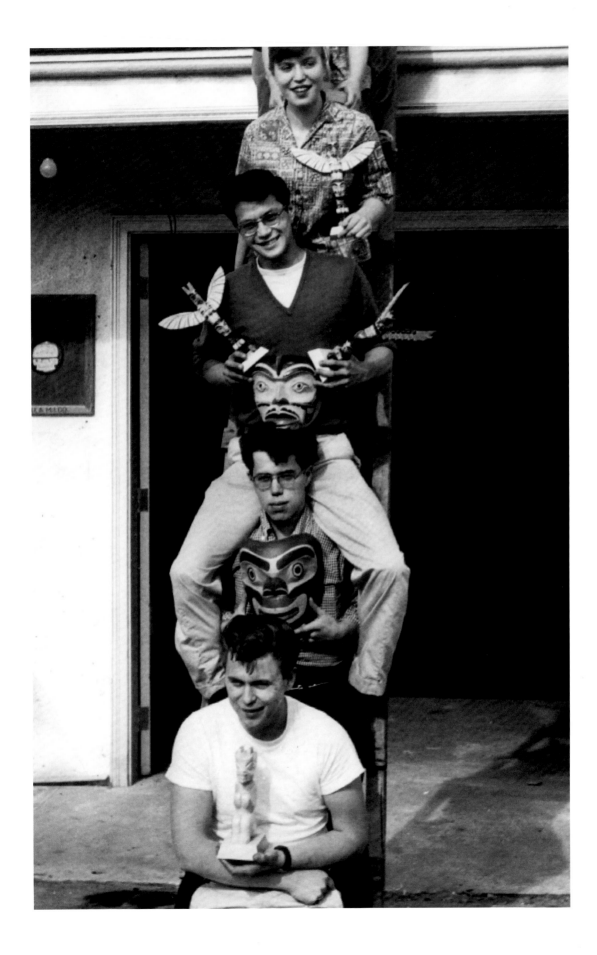

CONTENTS

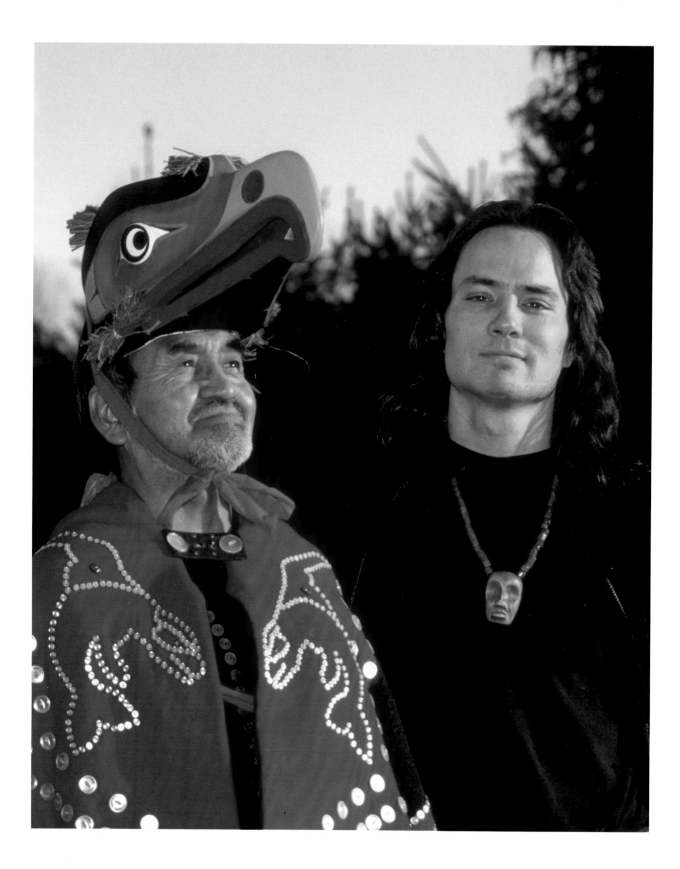

FOREWORD

THIS WARMLY WRITTEN memoir by Kwakiutl photographer, carver, painter, printmaker, and jewellery maker David Neel is a story of origins, birth, displacement, reconnection, and fatherhood. It is also a candid reflection upon his experiences as one among "the scooped generation" of Indigenous children who grew up separated from their Indigenous family members, often forcibly so. Neel's story is not, however, that of an adoptee or a residential school survivor, but of an infant whose ties to Indigenous family and community are attenuated as his young mother Karen Neel moves from Vancouver to Calgary in the mid-1960s following the sudden death of David's father, David Lyle Neel, in an automobile accident. The geographic distance between David Neel and members of his father's family necessarily engendered a cultural distance, a gap that David would bridge as a man in his late twenties.

Neel's peregrinations are vital to his art-making practice. Some of his earliest memories are of his father's work – modernist paintings and sculptures that innovatively combined elements of Western Modernism with Kwakiutl stories, colours, and compositions to create an urban Indigenous aesthetic. The autobiographical tale that the younger David tells reveals how these images were important to him as a young child. They allowed him to imagine connections to his father

facing

Chief Henry Seaweed (Kwakwa̱ka'wakw) and David Neel, 2004. The Eagle headdress was carved by David.

ix

and to Indigenous family members at a time when letters were rare and phone calls expensive. As a young adult, those very images inspired David to become an artist as well. Raised at a distance from his Indigenous family and its long tradition of carving, Neel took up photography – portraiture and photojournalism – moving further away to Texas and from Kwakiutl aesthetics. However, the sight of a Northwest Coast mask by Charlies James in a Fort Worth art exhibition in 1987 brought him home where he would be mentored in the art of carving.

What David did not know at that time was how vanguard his ancestors' artistic practices were. Charlie James is known for being among the first to develop a carving practice that catered to cultural outsiders; James's granddaughter, Ellen Neel, often called "the first woman totem pole carver" not only carved monumental totem poles, but she also developed a commercial practice that included decorative arts and textiles embellished with Kwakiutl designs. Her son, David Lyle Neel, was working towards a career as a graphic designer and political cartoonist at the time of his death. Through these innovations, the family as a whole is known for preserving the art of carving during the darkest days of its persecution.

Neel's artwork also visualizes the details of his biography. His celebrated book of photographic essays, *Our Chiefs and Elders* (1992), practically shouts the joy of his reconnection to Indigenous communities and his family members, while drawing upon the art-making practice that he had acquired before his return. David's more mature artwork brilliantly marries together different aesthetics. For the younger Neel, those conventions are informed by both photojournalism and carving, which he melded together with a mask series that draws on headline news stories, combined with characters from conventional Kwakiutl

tales. Celebrated pieces, such as *The Mask of the Injustice System* (1997), serve to convey the Kwakiutl stories of our times. That Neel's work so quickly garnered attention is because, much like the work of his ancestors, it is innovative and surprising.

Accounts of family and reconnection and renewal of Indigenous family life lovingly percolate throughout the book. The stories of his father and grandmother Ellen Neel arise in David's discussions of his painting and jewellery-making practices. These commemorative acts punctuate the book as "interludes," denoting the slippage across time. They are works located both in the present and the past. The continuum of time and family is also felt in the renewal of family practices, as seen in photographs of David working with his own children as his grandmother had done with hers. *The Way Home* is itself an artistic accomplishment, weaving the stories of his own life with longstanding Kwakiutl tales such as Mink and Young Thunderbird. Much like a classic Kwakiutl tale, the story of Neel's return is very much a tale worth telling.

CAROLYN BUTLER-PALMER
Art History and Visual Studies
University of Victoria
2019

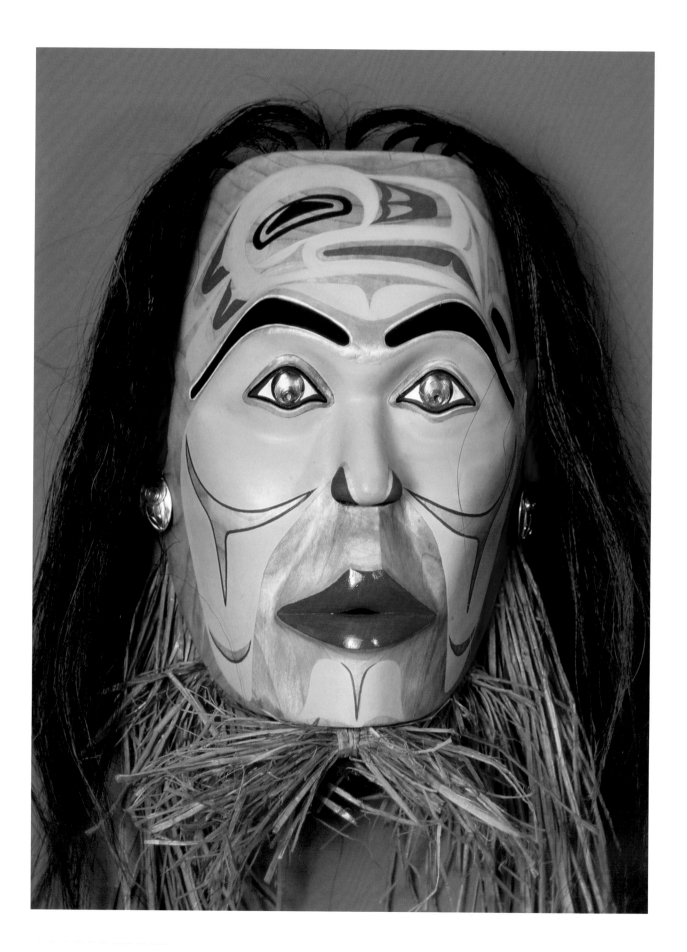

PREFACE

WHEN I BEGAN to organize the material for this book, it took a great
deal of soul-searching to decide what to include and what to leave out.
Initially, I thought the book would describe my unusual art practice,
which includes woodcarving, hand engraving, photography, writing,
painting, and printmaking. But I soon realized that an account of how
I found my way back to the traditions and culture of my father's people
after two and a half decades away was a story worth telling. My people,
the Kwakwa̲ka̲'wakw, the traditional inhabitants of the coastal areas
of northeastern Vancouver Island and mainland British Columbia,
have a rich traditional culture that includes masks, dances, canoes,
totem poles, stories, and much more. My father, an artist, returned to
the ancestors when I was an infant, and for many years I lost the con-
nection with that aspect of my life. Shortly after his death, in 1962,
my mother and I moved away, and I began a circuitous journey that
wouldn't take me back to British Columbia until 1987.

If my story were a typical one, like that of the many Indigenous peo-
ple who as children were adopted out or separated from their families,
I would have lived my life never knowing my father's family or our her-
itage. It is a rare thing for an Indigenous person to come home to his
or her people after decades away. In all cultures family and heritage
become undefined and intangible when you've been away for a long

facing
David Neel Self-Portrait mask, 1993
alder wood, paint, horsehair, cedar bark,
and copper, 20 × 11 × 7 in.

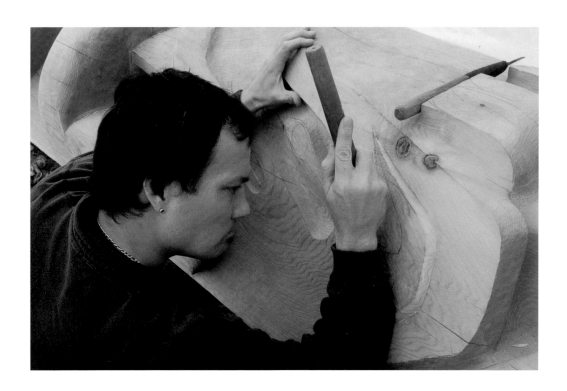

above
Carving a totem pole.

time. The sense of having a place of origin fades until it is a dim memory. But, somehow, I always knew I would reconnect with the people portrayed in my father's paintings – although it took me twenty-five years to realize how that could be accomplished.

Although I didn't have my father to teach me about our culture, I had the rich symbolism of his art, and it nourished my young mind and gave me a vision. Art communicates at an intuitive level through symbols, which can express gigabytes of information. Carl Jung says, "The underlying primal psychic reality is so inconceivably complex that it can be grasped only at the furthest reaches of intuition, and then but very dimly. That is why we need symbols." Symbols speak to the soul, to the primitive psyche, communicating coded messages that bypass the conscious mind to communicate to a deeper part of the brain.

Northwest Coast art is rich in symbols, and those symbols played an essential role in my early life, helping to form my emotional and psychological foundation. I grew up surrounded by my father's art, and although I had no one to explain the imagery to me, no one to teach me about the Trickster and the Transformer, those images spoke to me and affirmed that there were people and a culture that I belonged to. My father, his family, and our people were embodied in images of

masks, canoes, and dancers that communicated to some inner part of me, so that as a child I never completely lost touch with our culture – though I had yet to see an actual mask, a canoe, or a totem pole. My father's art represented that world, and it kept a small but persistent ember smouldering inside me, waiting to be fanned into a flame. And that moment would come, years later, in the most unexpected place, thousands of miles from home.

In 1986, I was living in Dallas, Texas, thirty-six hundred kilometres to the south, when was I called home by my great-great-grandfather Charlie James (Yakuglas). I was twenty-seven years old, I had a house, and I had a promising career as a photographer – I'd already had three solo exhibitions in Dallas. I sold everything, loaded up my Honda Accord, and drove north to pursue my vision of becoming a Kwakwaka'wakw artist, like generations of my family before me. I had no contacts and no game plan, just a burning desire to follow in the family footsteps. When I returned to British Columbia, I found that few Indigenous people are able to find their way home after many years away, and even fewer are able to immerse themselves in the traditional culture. How does a person go about reconnecting with long-forgotten relations and a culture that is distinct from and at times in opposition to non-Indigenous society? If that person were able to reconnect with their roots, would they find that the values, beliefs, and social norms were compatible with their own? And, most importantly, would they be welcomed and accepted by their people after being so long away?

In hindsight, it seems audacious to have expected to return and simply become an Indigenous carver, but my ability to believe in the improbable served me well. Through a combination of good luck and a stubborn nature, I was able to achieve my dream. How was it done, you ask? Well, that's an interesting story ...

4/70 © D. Neel 2017

A NOTE ON TERMINOLOGY

IN CANADA, THE TERMS that are currently used for First Peoples are *First Nations* and, more broadly, *Indigenous people*, while in the United States the terms *Native American* and *American Indian* are most often used. Similarly, First Nations people often refer to themselves as *nations*, while Native Americans often refer to themselves as *tribes*. I try to respect the terminologies used in both countries, and when I refer to people from both countries, I use *Indigenous people* or *tribal nations*.

Kwakwaka'wakw, which means "Kwak'wala-speaking people," refers to the people of the villages where Kwak'wala was traditionally spoken. Kwakwaka'wakw references to heritage can be confusing, so a few words about my tribal heritage are in order. I refer to myself as "Kwakiutl" because I am a member of the Kwakiutl Indian band of Tsaxis (Fort Rupert), one of the tribal nations of the Kwakwaka'wakw. Although my family has strong ties to Yalis (Alert Bay) (my father, Dave Senior, and my grandma Ellen were born there), we trace our roots and my band membership to the village of Fort Rupert. This doesn't change over time, so my children continue to identify themselves as Kwakiutl.

I have used the terms *mythology*, *legends*, and *traditional stories* interchangeably throughout this book to refer to the ancient stories

facing

Hummingbird and Bear Bentwood Box, 2017
serigraph on paper, 24 × 20 in.

Combined within this image are two of my long-time topics of research – cedar bentwood boxes and the ancient stories. Once there was a hummingbird who was bullied by a bear and kept from gathering nectar. So she gathered twigs, flew into his mouth, then down to his stomach, where she lit a fire before flying out again. The bear ran away with smoke coming from his mouth and never again bothered the hummingbird.

passed down within oral traditions. These terms come from a Western tradition of storytelling and may suggest different meanings to different readers. This is one of the challenges of writing in English about a culture that has its own languages and worldview. I have chosen most often to use the terms *ancient stories* and *traditional stories*, as they seem the most appropriate terms in English. All of these terms refer to the stories passed down orally from antiquity, and I understand them to be allegorical. They are metaphorical and contain timeless information and lessons that help us understand this complex world of ours.

I was first introduced to the traditional stories that appear in this book in 1987, when I started to apprentice with First Nations carvers in Vancouver. In the shop where I learned, there would often be a number of artists from a variety of First Nations, each working on his own piece, and someone would tell the story of the mask he was working on. Some were animated storytellers, not just when it came to the ancient tales but also about the old ways and the old-time carvers, such as Tom Patch Wa'miss, who has faded into history. I was hungry for knowledge in those days, and I used to listen attentively and make notes in my sketchbook, which I always kept with me.

In 1988, I started photographing chiefs and elders in British Columbia, and I met and listened to tales from a number of elders, including two of the old-time storytellers – Chief James Wallas (Quatsino) and Henry Geddess (Haida). They were storytellers from another era, a time before cable television, smartphones, and the internet, an era when people spent more time together and entertained themselves. When James Wallas and Henry Geddes told a story, it came to life, and I heard the echo of history in their words. By that time, I knew that the masks we carved, and the dances in which they

were used, were based on the characters and their exploits from the ancient tales. I had the good fortune to hear the legends first-hand from master storytellers, the likes of which no longer exist.

I had read world mythology since my early childhood, so when I discovered the rich heritage of Northwest Coast traditional stories, I wanted to learn as many as possible and gather them together as inspiration for my art. For over twenty years, I have been researching the legends with the idea of publishing them in contemporary idiomatic language, to make them more accessible to modern readers. I wrote the stories shared in this book over a number of years. They are Kwakwaka'wakw tales, collected from a variety of sources, both written and oral. A number of stories from my great-great-grandfather Charlie James were published at the turn of the twentieth century, and I still have copies of them. When I came upon the idea of including ancient stories in this book, I searched through the stories that I had written down over the last twenty years and reworked them (some of the stories can be lengthy) for a contemporary audience.

I felt they would help illustrate my journey because they are timeless metaphors. The ancient stories of the world, such as *The Epic of Gilgamesh, The Brahmanas,* or *The Iliad* and *The Odyssey,* all share one common theme: they help us understand our journey through life. They are not offered in the sense of a self-help guide; they do not tell us how to live a good life or manifest prosperity through affirmations. The stories come in the form of allegory and require interpretation and contemplation – when we hear the tales of Raven's gluttony and trickery and how it leads to a bad end, there is a lesson therein.

It should be noted that many versions of the same stories have been handed down over time, sometimes with only slight differences

between regions and tribal nations. The ancient stories are the inspiration for the masks, songs, and dances performed in Indigenous big houses today, and the right to display the masks and dances is handed down within family lines. Traditionally, the songs are familial property, although today they are shared among the Kwakwa̱ka'wakw tribes, and it has become customary to state the source and owner when a traditional song is used.

Lastly, in traditional Indigenous culture, family ties and ancestry are viewed and spoken of differently from those in non-Indigenous culture; for example, a cousin may be referred to as "Brother" or "Sister," and a great-grandfather or a great-great-grandmother may be referred to simply as "Grandmother" or "Grandfather." Family ties are important knowledge, and Indigenous people take pride in knowing their ancestors' names and heritage.

THE WAY HOME

1/ BEGINNINGS
FAR FROM HOME

THE YOUNG THUNDERBIRD

In the time of the ancient ones, a mighty Thunderbird came down from the sky world to live with the first ancestors. He was strong and wise, and he taught them many things, such as how to build the first big house. He took a wife, and they had a son, and they lived in the land of the Kwakwa̱ka'wakw. One day, the Thunderbird was called back to his home in the sky, and he flew away, never to return. The young boy, lacking the guidance of his father, wandered far from home until, like Odysseus of Greek legend, he had forgotten from whence he came.

After years of wandering, the boy's grandfather came to him in a vision, wearing the mask of Tsegame – the Great Magician of the Red Cedar Bark. Tsegame told the boy that his family was waiting for him and that it was time to return. The boy began the long journey home, and when he arrived, he found that he had been away not just for a few years but for two and half decades. Soon he met other descendants of the Thunderbird, and they taught him the ways of their people. The boy stayed in the land of his ancestors, raised a family, and eventually was transformed into a Thunderbird like his father.

facing

Holding the *Keeper of the Animals* mask in the bow of the *Walas-Kwis-Gila* after the dance performance on the Grand Canal at the Venice Biennale.

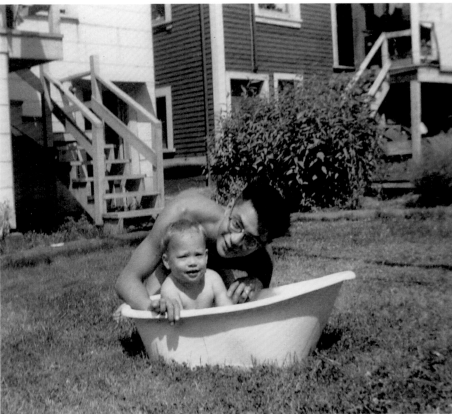

Sometimes, a single event can change the direction of one's life in a heartbeat. If things had unfolded differently, if the weather had been different, if the car had not started, if a phone call had not been received, or if any number of other things had or hadn't happened, how might the course of a life be changed? On September 10, 1961, my father, Dave Senior, passed away in an automobile accident in Mount Vernon, Washington. He was twenty-four years old when he returned to the ancestors. I was seventeen months. I have always believed that some part of him – some aspect of his spiritual or creative energy – was transferred upon his death. In an age in which scientific materialism reigns supreme, this belief may be dismissed as fantasy, but I believed it, and it influenced my life for years. From early childhood I felt that I had, in a sense, taken on the obligations of my father. Instead of fading into the ether, his creative dynamism was deposited in the unformed mind of his infant son, still an empty vessel at the time. Some part of the ancestral knowledge encoded in his DNA was transmitted to me.

The loss of my father had a major influence on my early years and helped determine the direction my life would take. It was many years

before I understood how unexpressed grief influenced my decisions in later years. All societies have ceremonies and customs that help us mourn the loss of a loved one and then move on. But infants and young children lack the emotional maturity to comprehend loss and experience bereavement as an adult would. This is not to say that children don't feel sorrow, but they have less capacity to identify or acknowledge the emotion and its effect. Later in life, this unexpressed grief can cause psychological complications; as adults, we may struggle to understand why we've made choices and decisions that, in hindsight, were clearly not in our best interest. In my case, the grief lay just below the surface for many years, influencing me in ways that I understood only in retrospect. Much later, when I was able to overcome that unspoken grief, it was like a great weight being lifted from my shoulders. I was in my thirties before I realized how my father's memory had the power to influence important decisions and life choices. It was as though that remnant of his spirit that was left behind wouldn't allow me to start living my own life until I made peace with it.

My earliest memories are of Dave Senior's art in our family home. Although my father was not there to care for me and guide me when I was a child, there was his art. Many of his paintings and carvings were on the walls of the family home, while others were stored under the stairs. When I was very young, I used to pull them out of their hiding place, lay them on the floor, and try to decode them. There was an oil painting of me as a smiling baby, which my father had completed when I was a year old. At that time, I didn't know I was Kwakwa̱ka'wakw or that only a day's drive away people were still carving cedar masks and dancing in fire-lit big houses.

Over time, I grasped what the art was trying to communicate to me – that it was beckoning me to find my way home. My father was not

facing left
DAVID NEEL SENIOR, *Thunderbird and Killerwhale* carving, 1959
yellow cedar, 34 × 16 × 14 in.

The carving depicts the two main crest animals of my family.

facing right
My father and I in East Vancouver, BC, 1962.

there to guide me or to teach me about carving totem poles, drawing ovoids, or painting canoes, but his art inspired me. The art that he left behind acted as a road map – as though he knew he wouldn't be there to assist me, so he left me clues encoded in his paintings.

Today, after working as an artist for thirty-five years, I view my father's paintings with fresh eyes, and I see clearly what he was trying to say to me. In vivid colours and sweeping brush strokes he passed on a love of our age-old traditional culture. Looking at his paintings as an adult, I see his desire to embrace something ancient and his longing to be part of that community. Over time, his yearning, his goals, and his aspirations became my own. My art became an extension of his.

AFTER TWO DECADES as a working artist, I was still influenced by my father's spirit. Starting in 2001, I completed thirty-four paintings on canvas, some up to two metres tall. I worked in both oil and acrylic paints, and while the paintings were contemporary in approach, they incorporated traditional elements and themes. I painted two series. The abstract paintings combined the familiar elements of Kwakwa̱ka̱'wakw art (splits, ovoids, and so on) with an innovative and painterly approach. The other series fused illustrations of mythic characters from the traditional stories with traditional elements and, sometimes, text.

Although these series were successful and were presented in three solo exhibitions at the CityScape Community Art Space in North Vancouver, the Indian Art Centre in Hull, Quebec, and the Grunt Gallery in Vancouver, I later wondered why I had put so much time into painting when I had, by that time, already established myself in photography, carving, and jewellery. It made no sense until I realized that, once again, I was trying to appease my father's memory, his spirit. My father

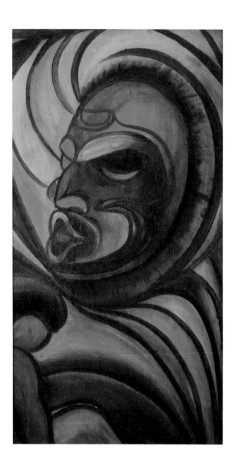

had been a painter, but he hadn't had time to complete a body of work, so, in essence, I completed it for him. When I look at my paintings of traditional stories from that period, I can clearly see his influence. I have often wished that I had invested that time in carving masks or another canoe, but once again my past predisposed my actions and my art. The time was not wasted, though, as my father's spirit now seems content.

MY FATHER'S LEGACY provided a sense of direction and purpose in my life. An important Kwakwaka'wakw tradition is the concept of making your name good. Originally, I thought of this concept in terms of caring for the family name over the course of a lifetime, but later, when I began to attend traditional ceremonies and learned first-hand about Kwakwaka'wakw culture, I realized that maintaining the familial name and the ancestral name that you inherit is a long-standing tradition. A name is important and carries cultural and historical significance. According to tradition, a name has a particular importance and meaning. It can be inherited or given, and it may be handed down from antiquity and often stays within the family for multiple generations. A high-ranking name relates to a position or "seat" within the potlatch or feast system, and it comes with responsibilities. In the case of a hereditary chief's name, the obligations may be extensive and require the hosting of potlatches, so supporting a "big name" can be expensive. A name also has a meaning. The traditional name that I inherited from my father, Gla-kla-kla-wis, means "Whales Coming Together Near the Beach," as Chief Alvin Alfred ('Namgis) once explained to me. Names are traditionally given at potlatches or feasts, and the recipient of a new name is required to dance. I took on my father's name at my uncle Chief Edwin Newman's potlatch in Yalis (Alert Bay).

The surname Neel and my traditional name (both inherited from my father) came, I believe, with a responsibility to learn about Kwakwa̱ka'wakw art and history and then pass that knowledge on to the next generation. My grandmother Ellen Neel (1916–66) used to say that she was a fifth-generation traditional artist, which would make me a seventh-generation artist, although I can recount the names of only five generations. My grandmother evidently had knowledge of two previous generations of artists, the names of whom have been lost to history. My knowledge of family history extends back to my great-great-grandfather Charlie James (1875–1938), whose work has become synonymous with what is commonly referred to as Southern Kwakiutl art (it is, more accurately, Kwakwa̱ka'wakw art). I have often wondered with whom he apprenticed, because his artistic style was highly personalized and unique for the period. He was a prolific carver at a time when traditional First Nations cultural practices were illegal under the so-called potlatch law (1885–1951) within the Indian Act, which made carving, singing, dancing, or any activities associated with the potlatch system punishable with fines or imprisonment.

Charlie James was immersed in the traditional culture during the time of the potlatch ban. He carved numerous dance masks that were used in the feast system, and many of them are now in public collections. In 1992, when I was in New York working on a commission for the National Museum of the American Indian, an art expert from Sotheby's was appraising a beautiful mask, Charlie James's *Crooked Beak of Heaven*. I immediately recognized the piece as my great-great-grandfather's work, and I asked the appraiser about its value. She told me she was estimating its value at a staggering us$250,000. A quarter of a million dollars for a piece of potlatch art created during a time when it was unlawful to carve masks! I imagine

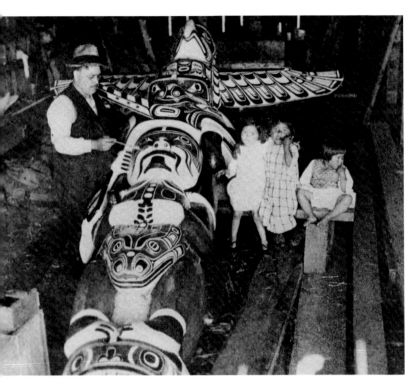

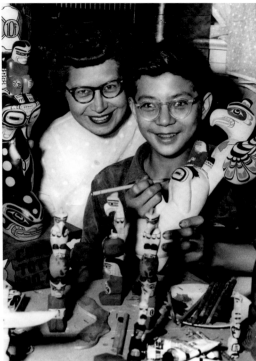

that Grandpa Charlie would appreciate the irony if he were here today. Charlie also carved numerous totem poles, both models and full size. During his time, elaborate carved memorial poles and installations were common in the graveyard at Alert Bay; he carved a number of them, and they can be seen in the black-and-white photographs that have survived. A few of his memorial poles are still standing in the graveyard, but they are in an advanced state of decay. However, one of his large totem poles can be seen at Canada Place in downtown Vancouver. It has been displayed indoors for many years and is still in good condition.

Much of Charlie James's work was photographed during his lifetime, some of it by the acclaimed "Indian photographer" Edward S. Curtis, who photographed Kwakwa̱ka̱'wakw culture extensively around 1914. Curtis's epic multivolume book, *The North American Indian*, featured photographs of a number of Charlie's masks and totem poles. For his 1914 feature film, *In the Land of the Head Hunters* (later retitled *In the Land of the War Canoes*), Curtis commissioned several major works from Charlie, including two house posts that served as the background in a number of scenes.

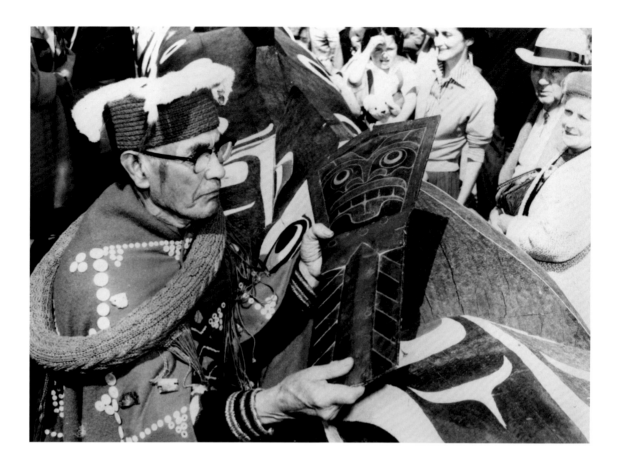

What is seldom mentioned is the fact that Charlie was a Christian and a deeply spiritual man. Around 1925, he carved a superb eighteen-foot totem pole and donated it to the Women's Auxiliary of the Church of England in Victoria, British Columbia. This was an extremely generous donation, indicative of his genuinely spiritual nature. The totem pole was displayed in the church for many years, until it was donated to the U'mista Cultural Centre in Alert Bay, where it can be seen today. Having spent its entire life indoors, it's in excellent condition and still has what appears to be the original paint – unlike most of his surviving totem poles, which have been repainted several times by people of dubious skill.

In 1990, while researching the collection of the Glenbow Museum in Calgary, Alberta, I came across a Charlie James totem pole that was unattributed. Unfortunately, someone had used a chainsaw to cut the pole into six-foot sections, evidently to facilitate moving it. I also found a major work of Charlie's in the Bronx, New York, where

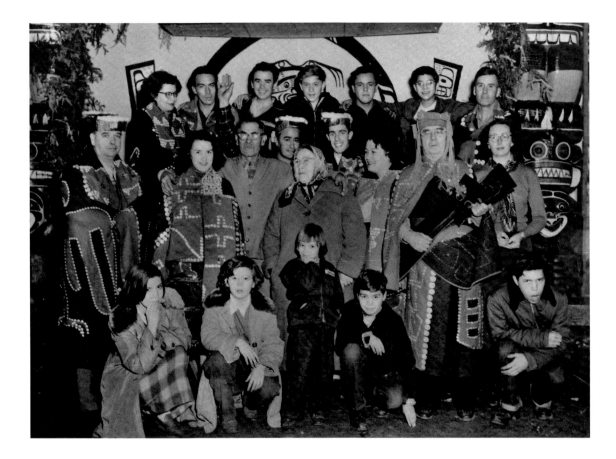

the Gustav Heye collection of American Indian art was stored at the time. While I was researching that collection, something on the top shelf of a long-forgotten storage room caught my eye. Standing on the top rung of a rickety step ladder, I lifted dust-covered plastic and found a treasure concealed within: a Charlie James articulated *Supernatural Halibut* mask. I knew that it was his work, although the Smithsonian Institution didn't have an attribution for it. Over the years, I have encountered Charlie's work in the most unlikely places, and although he's been gone for many decades, his carvings and his teachings have survived, and he has been a major influence on my art.

Grandpa Charlie passed much of his knowledge and his carving technique on to Mungo Martin. Mungo was the son of Charlie's wife by her first husband, and Charlie raised him as his own and taught him to carve in his distinctive style. Mungo in turn made the style his own, as did Charlie's granddaughter Ellen Neel. When he was young, Mungo assisted Charlie with a number of large carvings, such as the grave

above

A group photograph taken in 1953 at the first legal potlatch after the repeal of the potlatch ban. Hosted by Mungo Martin, the potlatch was held in his big house, named Wa'waditla, in Victoria. Shown in the photograph are (bottom row, from left) Theo, Cora, and Theresa Neel, Tony Hunt, and Ted Neel Junior; (middle row) Ted Neel Senior, Mildred Hunt, Mungo Martin, David Martin, Sara Martin, Wilson Duff, Helen Hunt, Tom Hunt, and unknown person; and (top row) Ellen Neel, Henry Hunt, Dan Cranmer, Bob Neel, unknown person, Dave Neel Senior, and unknown person.

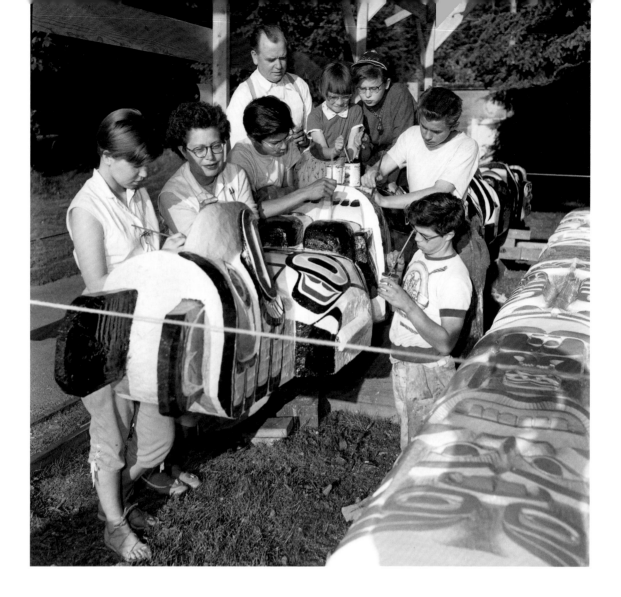

memorials that once stood in Alert Bay. Mungo's first major carving is believed to be the thirty-four-foot *Raven of the Sea* totem pole, which was moved from Alert Bay to the University of British Columbia, where Mungo was commissioned to restore it years later. In addition to hosting the first public potlatch (in 1953, soon after the repeal of the potlatch law), Mungo was an accomplished composer of traditional songs and has been credited with composing over two hundred of them. Some are still sung at our feasts today. One of his compositions, "Abaua'a," a song for his wife, is a beautiful, haunting melody that eloquently expresses his love for his life partner. The song is so powerful and stirring that the listener doesn't need to speak Kwak'wala to comprehend its significance.

My children Eddy and Ellena help me paint a totem pole, 2003. This photograph was inspired by the 1920 photograph (page 9) of my great-great-grandfather, Charlie James, carving a totem pole while my grandmother and her sisters watch, and by the photo of the Neel family painting a totem pole in 1955 (page 12).

For much of his life, Mungo worked in the fishing and logging industries, which were booming at the time. Although he was an accomplished carver from a young age, he didn't become well known until later in life, when he became known as "the last of the old-time carvers." Much of the work that he is known for today, such as the one-hundred-foot totem pole that was given to Queen Elizabeth and now stands at Windsor Castle, was completed towards the end of his career.

More fluent in Kwak'wala than in English, Mungo was a man with his feet in two worlds at a time when the traditional culture was just starting to flourish after decades of repression. He directly influenced the next generation of carvers, including Ellen Neel, Bill Reid, and Tony Hunt Senior. In the 1980s, when I visited Bill Reid at his studio, he talked about carving with Mungo. Mungo also passed much of his knowledge on to his own son, David, who died in 1959 in a tragic fishing mishap while still a relatively young man. It was a great blow to Mungo to lose his only son. Today, Mungo's work, his songs, and his memory continue to be revered, and he has been a role model and source of inspiration for me on my creative journey.

One of my earliest childhood memories of my grandmother is a visit to her carving studio. That visit, unfortunately, is also my only memory of her, although she would become a major influence in my life. Of course, on that August summer day, as we drove to visit Grandma Ellen, I couldn't comprehend the rich cultural heritage that she embodied. At three years of age, I only knew that we were visiting "Ada." It was 1963, and cars had wings and lots of chrome. Our dilapidated Thunderbird rolled to a stop in front of a well-worn East Vancouver home, and I was out of the car the moment the door was open. I wasn't aware of where I was, but it was an adventure, a break from the daily routine, and it was exciting. I wish I could recall the warm

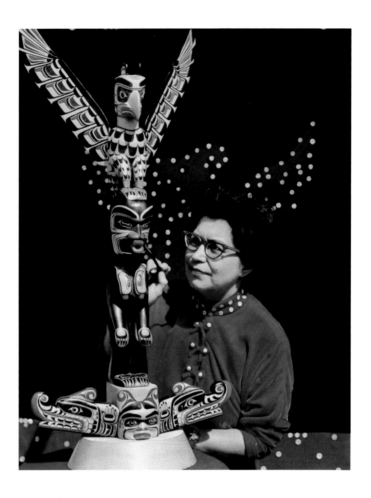

above
Ellen Neel putting the finishing touches on a model totem pole, one of her finest pieces, 1955. The figures, starting from the top, are Thunderbird, Dzonokwa, and Sisiutl.

reception that my aunts, uncles, and grandparents no doubt provided, but in my mind the visit is compressed into images and scents – the smell of yellow cedar intense and aromatic. If you have ever smelled yellow cedar, you know its distinctive oily, pungent odour.

My memory of what was said, the salmon we ate, and the house itself are blurry and faded, like an old Polaroid picture. But the carving shop in the basement (the site for her Totem Art Studios business) and the fragrance of yellow cedar are as vivid as if it were only yesterday. Psychologists call this an emotional anchor, a poignant recollection that contains much larger memories, like the code in DNA. I recall wading through cedar chips up to my chest. I was amazed: How could anyone fill an entire room with cedar chips? It must have taken years to accumulate so many, my three-year-old mind reasoned. I remember asking my grandmother, "Why don't you sweep them up?" And I clearly remember her reply, "We are too busy carving to sweep them up."

Evidently, she spent most of her time carving, and it was so important to her that she had no time for minor tasks such as sweeping, I reasoned. That one sentence is the only memory I have of my grandmother, the totem pole carver. Other people have memories of Sunday dinners, birthday parties, and eating Grandma's cookies. I had the scent of cedar and that single conversation, which was brief yet proved to be sufficient.

Ellen Neel is credited as the first woman totem pole carver, and the memory of her inspired me and encouraged me in my career. From the mid-1940s to the mid-1960s, she was one of the most active Northwest Coast Indigenous artists of the time, and her business, Totem Art Studios, did numerous public commissions as well as creating gifts for visiting dignitaries and celebrities and for customers such as the City of Vancouver. Ellen and the family also did a number of totem pole–carving demonstrations at public events, such as the Pacific National Exhibition in Vancouver and the Stratford Festival in Stratford, Ontario. In 1948 Ellen was well known in Vancouver, and the Vancouver Parks Board gave her studio space at Ferguson Point in Stanley Park, where she carved and sold her work.

In 1994, I was included in a group show, *Spirit Faces*, at the Inuit Gallery in Vancouver, which included the esteemed Haida artist Freda Diesing. I was an unestablished, young artist and it was a privilege to be exhibiting with an artist of Freda's stature. At the opening, she introduced herself and said that she was pleased to meet Ellen Neel's grandson. She explained that people often asked her if she was the first woman carver, and she always replied that Ellen Neel was the first and had been a source of inspiration for her. This meant a lot to me, as I had so little information about my grandmother at the time.

MINK, SON OF THE SUN

When Mink was young, the boys in the village taunted him mercilessly because he had no father. They teased him and bragged about their fathers taking them deer hunting, halibut fishing, and fur trapping. Such taunts never ceased to amuse the local bullies, because they could see how much they upset Mink, who longed to have a father. But Mink knew that he had a father; his mother had told him that the Sun was his father. Once, in frustration, he told the boys that the Sun was his father, and then they teased him relentlessly. "Mink, Mink, son of the Sun," they chanted endlessly, until he took refuge in the forest, where he couldn't hear their mocking words. Mink's mother knew that the boys bullied Mink, but she was helpless to make them stop.

One day, Mink decided that he would visit his father, and he had an idea about how to get to the sky world, where he lived. His mother's eldest brother made the finest yew-wood bows in the village, and Mink asked his uncle if he could borrow his bow and a large quiver of arrows. Mink waited until sunset, when the Sun was low in the sky, and he shot an arrow high into the air, where it struck the sky world. He shot another arrow into the back of the first, then another, and many more until he had a rope of arrows that reached the ground. Then he climbed up the arrows until he reached the sky world. In the distance, he saw a big house shimmering brightly, and he walked towards it.

As he drew close, he saw his father, wearing large abalone shell ornaments that sparkled and glistened, casting sunlight on the world below. His father immediately recognized Mink as his son. He said that he was growing old and weary and asked Mink to walk from east to west for him in the morning. Mink agreed, and early the next morning he put on the shimmering abalone shell ornaments and started walking towards the

west. Before he left, his father warned him to keep a constant pace and not to walk too fast or too slow. Mink agreed and set off enthusiastically. After a while he became tired and started to slow down. The earth below became scorched, and the rivers boiled. His aunts, the clouds, were curious and came to see who was walking instead of the Sun; this annoyed Mink, and he shooed them away, and again the earth was blackened. The Sun, who had been resting, heard the cries and screams from those below who were roasting, and he came and found that Mink was walking slowly and burning up the earth. He was furious and told Mink that he had no use for a lazy and useless son. He hurled Mink down to earth, where he splashed into the ocean. Duck, who was a friend of his, swam out to retrieve his friend and brought him back to the village. Ever since, the Sun walks daily from east to west at a steady pace and doesn't scorch the earth.

My father, Dave Senior, and my mother, Karen Clemenson, were married at a young age: she was only sixteen years old, and he was twenty-one. My mother loved to tell the story of how they had met on a sweltering summer day at a swimming pool at a Vancouver park. Mary, her friend, was an acquaintance of my father. Mary jokingly said to my mother, "Let's throw Dave in the pool." My father, hearing this, replied, "What did you say?" My mother, the quick thinker, added, "Isn't the day cool." Dave wasn't buying it and threw my mother in the pool. They were married a year later.

Because of my father's untimely death, my parents weren't married for very long. My mother became a widow and a single parent at the tender age of seventeen, when many young women were thinking

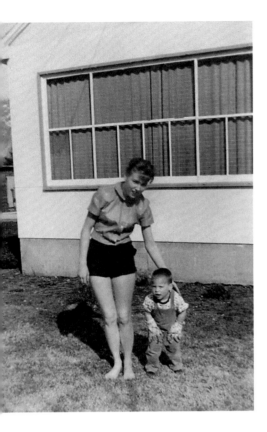

above

My mother, Karen, and I in
Castlegar, BC, 1963.

facing

Acrylic paint on board, 24 × 20 in.

My first piece of Northwest Coast
Indigenous art, painted in 1969, when
I was nine years old. It is based on a
Chilkat blanket that I saw in *National
Geographic*.

about what they would do after high school and considering what college to attend.

Many of my earliest memories are of making art. I started doing sketches based on my father's paintings at a young age. In my drawing and painting, I re-created our family and a fantasy world that I could escape to. We didn't have a lot of money in those days, and at times I didn't have enough sketch paper, so I would complete a drawing, erase it, and do another one on the same piece of paper until it was thin, frayed, and torn. In addition to sketching my father's paintings, I copied images of Northwest Coast art that I found in books. I still have an acrylic painting that I did when I was nine years old, in my Grade 3 art class, which was based on a photograph in *National Geographic* of a Chilkat dance blanket. The teacher praised my work, and I told her about my father and the First Nations heritage that had inspired me to do the painting. I can recall the skepticism that I saw in her eyes and the sense of loss that I felt.

I had no real memories of my father, no emotional anchors to attach his memory to. His touch, the scent of his aftershave, and his smile existed only in my imagination. He was not a real person in my mind; he was like a mythical figure, like the ancient story of Mink, Son of the Sun. I knew his face from the grainy black-and-white photographs that were stuck into a tattered photo album with *Kodak* embossed on the cover. We had the usual poorly composed, overexposed, and ill-focused images of the time. But there were a few photographs of my father's family taken by newspaper photographers in the 1950s and 1960s. They were images of Grandma Ellen, Grandpa Ted, my aunts and uncles, and my father carving totem poles, large and small. Those few images were treasures to me, and they were rich with clues about my

facing

A visit to a friend's farm, 1963. I vividly recall being chased by a rafter of turkeys and climbing a fence to escape them.

family heritage and a missing culture. I looked at the youthful faces of Uncle Bob, Uncle Ted, Aunt Theresa, and the others, of whom I had no recollection, and I wondered what they were like and where they were. I pondered the function of the mysterious tools in the photographs, the elbow adze and the D-adze used to carve masks and totem poles – tools that I would use two decades later but remained a mystery to me at that time. Bits and pieces of images floated around in my mind as I struggled to make the pieces fit together, as I tried to understand how dance masks, big houses, and a family of carvers related to my world.

OMEETLAMAY THE SHAMAN

There was once a young boy, Omeetlamay, who had a strict father. One day, Omeetlamay was sent by his father to collect seagull eggs on the cliffs near the beach. He had almost filled his cedar-root basket with eggs, but on the way back to the big house he became hungry and ate some of them. When his father found out that the boy had eaten the eggs, he was furious and beat Omeetlamay in front of their neighbours. The boy was humiliated and ran into the forest. He bathed in a mountain stream to wash away the shame that he felt. Then he walked deeper into the forest and bathed in a river. After he had done this four times, he found himself at the base of a high mountain. He climbed to the summit and stayed there for four days.

On the last day, he heard a strange whistling noise, and to his surprise a piece of crystal fell from the sky and struck him on the head. (Crystal is used by shamans and is known to have supernatural properties.) Suddenly, he was floating above the ground, and then he transformed into a bird and could fly. He flew back home and soared between the houses. Omeetlamay's people saw him as a supernatural bird and tried to capture him with

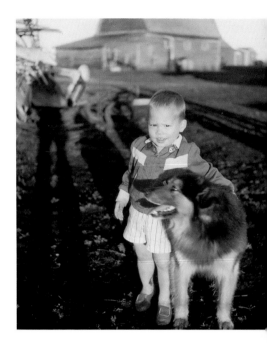

large cedar baskets, but he was too quick. At last, they set a perch on top of his family's house, and he alighted on it and transformed back into a man. Omeetlamay's family was overjoyed to have him come home with supernatural abilities. He found that he had been away not for a few days but four years, and he stayed and became a powerful shaman.

Shortly after my father's death, my mother and I moved to Castlegar, BC, where her mother, Ann, was living. She was a supportive mother and enjoyed having her grandson living in her home. A year later, my mother married a non-Indigenous man named Brian, and we moved again, first to Lethbridge and then to Calgary, Alberta. School age by then, I attended public school in a working-class neighbourhood in Calgary, where political correctness and racial equality were unknown. Movie theatre concessions sold candies called "nigger babies," while the corner store was referred to as the "Chink store." When I was young, I looked "ethnic," and comments like "You look like a chink" and "Are there still Indians around?" were not uncommon.

Not long after their wedding day, Brian became abusive and violent. He got worse over time, and before long we were living in an environment of fear and domestic violence. I recall waking up one morning to find that a hole had been punched in the kitchen wall, and I struggled to imagine the scene that must have transpired while I slept. My mother and Brian had two children, Bruce and Dana, who were four and five years younger than me. When we were young, we spent a lot of time together, and I have fond memories of making pancake breakfasts for the three of us on weekends. We had a good sibling relationship, although they had no understanding of how different my father's

family and cultural heritage were from their own. So, although it remained clear in my mind that my father was Dave Senior, the artist who had made the paintings and carvings in our home, I grew up in a mixed family with my mother's abusive husband.

Brian never hit his own children, but he didn't show the same restraint when it came to his "half-breed" adopted son. I dreaded summer vacations. He had a truck and camper, and when we went on vacations, I was in close contact with him for up to two weeks at a time. One day, Brian and my mother were in the cab of the truck, and my brother and sister and I were riding in the camper. I was drawing at the kitchen table, and my brother and sister were playing and making a lot of noise, as children sometimes do. Suddenly, the truck swerved sharply to the side of the road and came to a stop, and I knew we were in trouble. As I sat, fearing what was to come, Brian burst into the camper in a rage. He accused me of being the cause of the noise and ordered me to stand up in front of him. I was petrified and refused to do it. He said with sneer, "What's the matter? Are you a coward? Are you afraid?" I realized that compliance was unavoidable, so I slowly stood up. I was about eight years old, and he towered above me, looking down at me with disdain. Then, with no warning, he punched me in the chest so hard that I flew backwards, hitting the door with such force that it sprung the latch and burst open, and I was airborne.

I vividly remember my surprise at being in the air, and then the sharp pain as I crashed onto the asphalt of a highway rest stop. Immediately, I felt my consciousness leave me. Victims of childhood abuse report feeling like they are outside their bodies, and that is what I felt – as though I was watching myself lying on the ground, not really experiencing the pain personally. Mostly, I was shocked to find myself on

the ground outside the camper, when only a moment before I had been standing inside.

Then an adult was there, asking me if I was all right. I remember looking up to see a man kneeling over me with concern in his eyes and a woman, evidently his wife, standing behind him. Strangers. I felt shame and embarrassment as I lay on the ground, disoriented and utterly vulnerable. In a moment, Brian was there, explaining that everything was okay – just normal. Then my mother was beside me, holding me, telling me it was going to be fine. I was terrified and crying loudly. It was so confusing, and so much seemed to be going on. The man was very agitated and spoke loudly, telling Brian that he'd seen me fly through the air and hit the ground. He knew that there was no reasonable explanation, and he saw it for what it was: child abuse. He was angry and said that he wanted to call the police. But Brian denied that anything violent had taken place, and things escalated. By now, everyone at the rest stop was watching the drama that was unfolding. I was frightened and paralyzed with guilt because I felt that I was to blame. It seemed to me that the Good Samaritan was angry at *me*, that I was the cause of the excitement. It would be many years before I was able to recall that incident and view it with detachment and under-standing. Now, when I think about it, I wonder, how much force is required to strike a child and cause him to fly through a closed door?

My childhood was punctuated with violent incidents like this, and I grew up in fear of Brian and his rages. My mother often protected me, putting herself between Brian and me, which momentarily deflect-ed his rage towards her. More than once I saw him strike my mother, and watching her being struck was worse than being beaten myself. I dreamt of the day when I would be an adult and I could defend her.

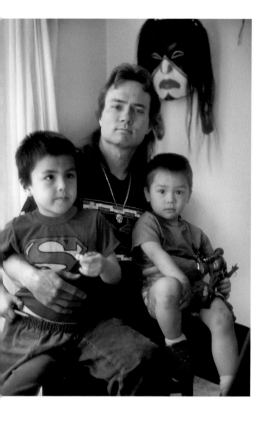

Brian's abusive tendencies made my childhood home feel like a foreign place, like I didn't belong there. Once, I remember Brian's parents coming to visit and bringing gifts for my brother and sister but not for me. They explained, "You are too old for toys." I was seven years old.

The trauma that I experienced in my early childhood caused me to experience symptoms of dissociative disorder as an adult. This condition is common among survivors of early childhood trauma, including Indian residential school survivors. It is a psychological coping mechanism that develops in response to distress when the mind creates separate compartments to store memories of traumatic incidents. In severe cases, the psyche may develop distinct personalities, each unaware of the others. I have seen the shift from one persona to another in an adult who attended residential school, and it is unsettling to witness.

In my own case, the memories of violent incidents from my childhood, and the emotions that accompanied them, were effectively walled off, compartmentalized in my mind; some were accessible, and others were not. For example, the camper incident was inaccessible to me until I was an adult. I had no recollection of it until decades later, when my sister commented on an event from that day, and the memory suddenly came back in its entirety. My mind had kept that painful memory from me for much of my life, but when it was released, every detail was vividly intact. I can remember the colour and the texture of the asphalt where I lay on the ground.

Because of that early childhood trauma, I experienced psychological compartmentalization, a condition where different mental compartments responded to situations and triggers. Later, I would sometimes wonder why I did something or said something or, more

importantly, why I had made a poor decision. The psychological influence was imperceptible, and it was decades before I realized that my decision making was being subtly influenced by emotional triggers that predisposed my choices. I would revisit a decision I'd made and wonder why I'd made such a bad choice – like impulsive behaviour in slow motion. During childhood, my mind had learned to wall off memories and emotions as a coping mechanism, so that as an adult I could completely forget people and events from the past – like closing a door and never looking back. It took me many years to realize that my troubled childhood was like a load of bricks that I carried with me and that I had the ability to put the load down any time I chose.

I knew that people who suffered early childhood trauma tend to, as adults, unwittingly create the conditions of the home they were raised in. When I became a parent, I made the decision not to allow a difficult childhood to negatively influence the way I raised my children. In the home of my childhood, I never heard the words "I love you." Later, I came to understand that my mother wasn't able to say those words because she grew up not hearing them. From the time my children were young, I told them every day that I loved them. They are adults now, and while their childhood wasn't ideal, they knew that they were loved, and I never once raised my hand to them. When I look back at the years in Alberta, it doesn't seem that it was my life; it's like recalling in vivid detail a movie or a novel of someone else's life. Those early memories just don't resonate with the person I am now and the life that I have led; the gap between the two realities is just too large to imagine that they are linked.

Fortunately, that chapter of my life ended when I was thirteen years old. I came home from school one day, and my mother told me

My children Edwin and Jamie with me in North Vancouver, BC, 1994. The *Lonefighter* mask can be seen in the background.

that she and Brian were getting a divorce. I can recall my feeling of relief and elation. The divorce was unexpected, and it seemed too good to be true. I saw Brian a handful of times after that, and over time he became just a bad memory.

WHEN I WAS YOUNG, in the days before both parents had to work to make enough to support a family, my mother was a homemaker. I recall her darning holes in socks, using a drinking glass inside the sock as a stretcher, a skill long forgotten today. Later, while still married, she went to work, and she became part of the first wave of North American housewives who went to work to augment the family income. This gave her a taste of independence and the realization that she could be self-supporting and raise her children on her own, which she did after the divorce. She became a single parent at a time when there was a social stigma about being divorced and people thought it noble to stay unhappily married "until the children grow up."

Being a hard worker and personable, she did well in the working world, eventually becoming the national sales manager for Nabisco Brands – no small achievement for a woman lacking even a high school education. As a result, she was able to support my brother, my sister, and me, even though she was a single parent. (Interestingly, I would repeat this cycle two decades later, raising my three children on my own from their infancy.) As a strong, independent woman, my mother passed on to me an ability to believe in myself. At age twenty-nine, she was already a widow, a divorcee, and a single parent with three children. My brother and sister were younger than me, so I assumed the role of the man in the family, helping to care for them.

My mother was of European Canadian heritage, and she didn't have a lot of knowledge to share about our family history and ancestry.

When I asked her mother, Grandma Ann, about our family heritage, she would reply, "Oh, I don't like to think about the past." Grandma Ann's childhood and our family heritage were locked in an emotional closet that she didn't like to visit, so our family history stopped with her generation. She made references to our Swedish or French roots, but they were vague, and I eventually stopped asking. This was in stark contrast to the family tree on my father's side, a family heritage that I was able to trace back several generations.

To bring in extra income, my mother rented out the basement bedroom. The Alberta government had a program through which students from rural Indigenous reserves boarded with families in the city to attend high school. For a couple of years, we had students from the Tsuut'ina Nation live with us, first Christina and later Jake. Formerly known as the Sarcee, the Tsuut'ina Reserve was just a few kilometres west of Calgary. I was fifteen years old at the time, and it was the first time since my early childhood that I'd seen another Indigenous person.

Christina and Jake were different from the non-Indigenous people I knew in Calgary. They had a different bearing and way of carrying themselves, and their outlook on family and community was unlike that of the people in mainstream society. Getting to know them was my first exposure to First Nations values, and I was eager to hear about life on the rural reserve. I asked endless questions, especially of Jake, who was keen to share his knowledge. They told me about life on a rural reserve, and the disparity between the First Nations and the rest of Canadians became apparent. As they told me about their life and family, I realized that reserves were like another world. How difficult it must have been for teenage students to move away from their family and community to an unfamiliar home and school in the city, where

they were the only Indigenous people. Christina and Jake were my introduction to the cultural divide that exists in Canada, and I realized that there was a dark, unspoken side to Canada's relationship with Indigenous people. This realization came as a shock, as it challenged everything that I had been taught. It was difficult for me to accept that the government viewed First Nations people as the "Indian problem" and that we were all but invisible to most Canadians.

I started to research and read about Canadian Indigenous history. I learned about Prime Minister Pierre Trudeau's 1969 White Paper, which sought to assimilate Indigenous peoples; the Sixties Scoop, which removed children from their families to raise them in foster care; and Indian residential schools, which placed generations of children in institutions that were little more than prisons and which operated in Canada until 1996. I struggled to incorporate this new information into my youthful worldview, but it didn't compute because it contradicted what I had been taught in school and by society. I'd been raised to believe that Canada was the most democratic and free country in the world. I couldn't accept that Indigenous Canadians had been subjected to government policies that sought to extinguish them both culturally and bodily. Once I knew how Canadian society truly functioned, it was like a tap that had been opened and couldn't be closed.

As the years passed and I continued to learn, I experienced a form of survivor's guilt – a bit like what soldiers can feel on being alive after seeing their friends suffer or die in battle. I felt guilty for growing up middle-class (actually, lower-middle-class) while so many other Indigenous people suffered. This guilt stayed with me for many years and influenced my life in ways that I understood only in hindsight.

SIWID'S JOURNEY

There was once a chief who constantly belittled and berated his son, Siwid. The chief expected Siwid to outdo the other children in the village because he was a chief's son. Late one night, another tribe attempted to raid the village, but another young man woke up, heard them, warned the people, and averted disaster. The chief was furious that Siwid had been outdone and rebuked him publicly. Siwid was ashamed and left the village in disgrace.

He walked into the forest, not stopping for days. Eventually, he came to a large lake, where he sat down and rested. Soon, bubbles started coming out of the water, and then a huge supernatural frog appeared. The frog told Siwid that he knew of his troubles and would help him. He instructed Siwid to climb on his back so he could take him to the world under the sea. Down, down they went to the bottom of the sea, where he met Komokwa, the Lord of the Undersea, who ruled over the animals of the ocean. He heard Siwid's tale, took pity on him, and gave him supernatural abilities and treasures.

Siwid stayed in the undersea world, went on many adventures, and overcame all his foes with the supernatural power that Lord Komokwa had given him. But after a while, he began to miss his home, and he asked the frog to take him back to the surface world. He returned to find that he'd been away for many years, and he showed his father and his people his treasures and his supernatural abilities. His father was proud, and Siwid was admired by the people of the village. His father later passed his chieftainship to Siwid, who became a great leader.

Despite the challenges of my early childhood, I developed into a young man with a naive belief in myself. This self-confidence was based on no prior positive life experience: I hadn't had good grades in school, I wasn't good at sports, and I'd had very few positive role models. But when I was eighteen, I took up weightlifting, which helped me develop self-discipline and self-confidence. It was the early days of the fitness revolution; *Pumping Iron* was in movie theatres, and Arnold Schwarzenegger was inspiring a generation to hit the gym. Weight-lifting itself was not the sole source of inspiration; it could have been tennis, hockey, or any other endeavour that taught discipline and determination. But I discovered that with hard work I could influence my life, just as I had influenced my physical body. I was a young man just out of high school, and as my self-reliance grew, I was eager for knowledge and experience.

We lived in a three-bedroom, single-storey house with an unfinished basement. My brother, sister, and I were teenagers, so the family home was beginning to seem a bit cramped. I had never built anything or even swung a hammer, but somehow I convinced my mother that I could undertake a major renovation on my own. For some reason, I didn't see my lack of skill and experience as a deterrent. I soon figured out how to hammer together two-by-fours, and I transformed the concrete box of a basement into several rooms, including a den, bedroom, laundry room, and storage room. Then came the insulation, the wiring, the drywall, a ceiling – all with techniques learned from a handful of how-to books. The only part that I didn't do myself, thankfully, was the wiring. For that, I worked out a deal with a friend from high school who was apprenticing in the trade. Over the course of a summer, the basement was transformed into a decent-looking, though basic, basement suite constructed mostly with verve and very little know-how.

My mother evidently had a lot of faith in me, although I'm not sure why, as few parents would have allowed such a construction project to be undertaken by an inexperienced teenager.

With the basement renovation a success, I decided to add a dining room off the kitchen by renovating one of the bedrooms on the main floor. The first step was to remove the wall separating the kitchen and the bedroom, and I thought a chainsaw would be the quickest way to do it. Of course, there were electrical wires and nails in the wall, and it never occurred to me that I should turn off the electricity at the fuse box first. With a rented chainsaw, I began to cut through the wall and, of course, I hit electrical wires. With a dramatic display of sparks, the breaker blew, and all the lights in the house went out. The nails in the wall had ruined the chain of the saw, so the rental store made me pay for a replacement, and I learned that a chainsaw is not the tool to use for interior work. After getting off to a shaky start, I eventually managed to finish the dining room, and by then I was an "experienced" handyman with two projects to my credit.

Years later, I struggled to understand why lack of experience had never stopped me from taking on new projects. In my early years, I was a voracious reader of world mythology, which influenced my character and worldview into adulthood. I didn't have access to the traditional Kwakwa̱ka'wakw stories that my father had grown up with, but I read ancient Greek, Norse, and even Japanese legends. I understood intuitively that the legends were metaphors and were not to be taken literally. For example, the archetypal brave knight slaying the dragon symbolizes the process of overcoming inner fears and demons. Instinctively, I knew that the great obstacles that the heroes faced were metaphors for the challenges I faced in my own life. In the words of mythologist Joseph Campbell: "Shakespeare said that art is a mirror

held up to nature. And that's what it is. The nature is your nature, and all of these wonderful poetic images of mythology are referring to something in you." I understood that legends help us comprehend and overcome the challenges of our everyday lives; that knowledge, in turn, helped me believe that anything might be possible, even though I had no experience and few skills. While I had missed the traditional stories and the teachings of my elders when I was young, I was able to find the essence of their lessons in world mythology, and that helped set the course of my life.

NU-MAS-EN-KWAL-IS AND THE FIRST ANCESTORS

In the time of myths, Nu-mas-en-kwal-is (Old Man Among Us) came down from the skyworld and lived with the first Kwakwaka'wakw. He built a big house and raised a totem pole in front, with two live eagles on top, watching over the village. He had four children, and the eldest was a daughter named Shining One, who was blind. One day, she wanted to pick berries on a nearby island, so she asked two of her father's slaves to take her there by canoe. As they paddled away from the village, they could hear the screeching of the eagles on the totem pole, and the sound grew fainter as they went farther out to sea. They travelled for many hours, and Shining One said to the slaves, "Shouldn't we be there soon?" They told her that they were lost, but the slaves were actually escaping from her father.

After travelling for many days, the slaves saw land in the distance and they went ashore in front of a huge big house. It belonged to a man named Copper Maker, who went out to greet his guests and invite them inside for salmon, seaweed, and fish oil. The slaves departed early the next morning and left Shining One behind.

Later, Shining One became Copper Maker's wife, and they had two boys, who grew up to become magnificent hunters. One day, they asked her where they came from, and Shining One told them of her village and their grandfather, Old Man Among Us. The boys decided that they would visit their home village. Their mother told them which way to go and to listen for the two eagles screeching on top of their grandfather's totem pole. Their father gave them many gifts to take on their journey, and they loaded their canoe with the gifts, food, and water and set off.

After paddling for four days, they heard the sound of eagles far away. They paddled towards the sound until, in the distance, they saw a village. As they drew closer, they saw the totem pole with the eagles on top, screeching excitedly as they saw the approaching canoe. When they came ashore, the people were wary of the newcomers, but after they heard that the grandsons of Old Man Among Us had arrived, they gave the boys a warm welcome. Their grandfather was overjoyed to see them and asked for news of their mother. They said she was happy and gave him the gifts they had brought, which included valuable coppers that their father had made. The boys stayed and lived in their grandfather's village for several months, but eventually they became homesick. Their grandfather filled their canoe with furs to give to their father, and the boys paddled away with the sound of the squawking eagles fading behind them.

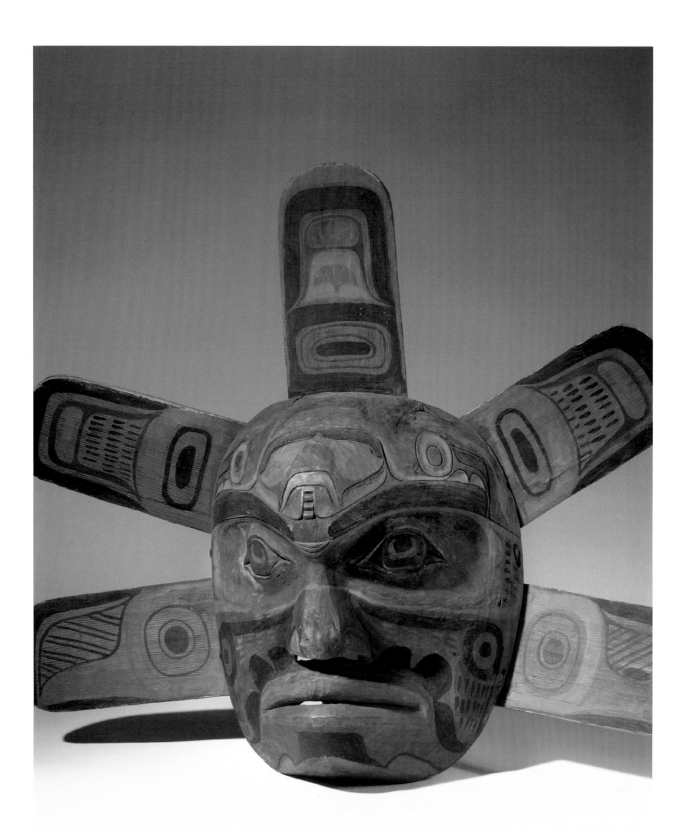

2/ **PHOTOGRAPHY**
TRANSFORMATION

THE STORY OF MAT-EM

There was once a young boy named Mat-em, who loved to eat salmon eggs. One day, he was roasting salmon eggs by the fire while his father sat nearby, warming himself. Suddenly, some of the eggs burst with a loud popping sound and burned his father, who became very angry. His father picked up a stick used to tend the fire and beat Mat-em.

The boy felt dejected and sad, and he walked in the forest until he came to a spot in the river where a log-jam had piled up, creating a dangerous blockage. Mat-em was so depressed that he wanted to drown himself, so he jumped into the river above the driftwood. To his surprise, he reappeared below the log-jam, unharmed. Confused, he walked on until he reached another log-jam in the river and jumped in again. Again, he mysteriously surfaced unharmed below the log-jam and swam to shore.

He continued walking until he reached the base of a tall mountain, which shone like a light against the skyline. As he climbed the mountain, he saw that it shone because it was made of crystal, which was highly valued by his people and was known to have supernatural properties. He continued to climb, and pieces of the crystal began to stick to him – at first, a few pieces stuck in his hair, then more on his back, until his whole body was covered in crystal. By the time he reached the summit of the mountain, he

felt buoyant, and then he found that he could fly. Excited by this newfound power, he flew faster and faster until he was far from his homeland, and he kept going.

After a few days, Mat-em had flown all over the world and had seen amazing things, but he became homesick. He flew back to his village to find that he had been away not for a few days but for four years. When he reappeared before his people, he assumed the shape of a pure white eagle and flew about the village. The people tried in vain to catch him. He told them, "Purify your houses and mount a perch on the biggest of them, and I will return." After the houses had been purified, Mat-em landed, entered the chief's big house, and was welcomed by the community, who were awestruck by his supernatural abilities. He told the people of his adventures and showed them the dances he had learned from the four corners of the world, and they feasted for four days.

My first experience with photography was in a photojournalism class at Calgary's Mount Royal College in 1980. As a journalism major, I thought it would be useful to learn to take photographs to accompany my writing. I completed the first assignment, developed the film, and made black-and-white prints, which were displayed in the classroom with the work of the other students. The instructor asked if I had done a photography class before, because my prints looked more advanced than the other students. After the second assignment, I knew I wanted to be a photographer. I took the money I had saved from my summer job and bought a new Nikon camera, a flash, several lenses, and a camera bag. At that time, I was thinking of changing my major to photojournalism, and I wanted to know more about being a press photographer, so I called up the local daily newspaper, the *Calgary Herald*,

spoke to the photo editor, and asked if I could come by and ask him some questions about pursuing a career as a photojournalist. He was very generous with his time and told me about the news business and what it was like to be a photojournalist. His advice was enlightening, and after long consideration I decided that photography, with my arts background, was the right career choice.

I researched universities that offered degrees in photojournalism, and I applied and was accepted to the University of Kansas at Lawrence, which had one of the best photojournalism schools in North America. In the summer of 1982, I loaded everything I owned into my second-hand Toyota Corolla and, with a letter of acceptance from the University of Kansas in the glove compartment, crossed the border and drove towards the heartland of America. I was twenty-two years old, I didn't know anyone in America, I'd never travelled far from home before, and I'd never made a long-distance road trip, but I left everything and everyone I knew behind and headed south. After driving two thousand kilometres, I arrived in Lawrence. I was hardly the first Indigenous person to go to school there: the city was the location of Haskell Indian Nations University, which had opened in 1884 as an Indian boarding school (similar to Indian residential schools in Canada). Its mission, according to army captain William Henry Pratt, had been to "kill the Indian to save the man." I was naive and unfamiliar with American culture and geography, so I was surprised when several local people asked me, "Why did you come to Kansas, of all places?" After a few months there, I realized that Kansas did not rank as an international travel destination. But this was before YouTube, Google Maps, and Wikipedia, and having learned most of what I knew about America from television and movies, I thought every place in the United States was like Los Angeles or New York.

But the university had good professors, and I was exposed to many types of photography – commercial, photojournalism, and fine art, which broadened my understanding of what photography could be. Most importantly, the University of Kansas had a very large art library with several hundred photography books. I studied photojournalism and fine art photography, taking out dozens of books every week and spending many hours looking at the images, which formed the foundation of my approach to photography as a creative medium. I developed an appreciation for the images and philosophy of the Concerned Photographers, including Cornell Cappa, W. Eugene Smith, and Henri Cartier-Bresson. They believed documentary photography and the eloquence of the still image could awaken within people an awareness about the world that would lead to the betterment of society. I tried to apply their philosophy to my own documentary projects, although, three decades later, I wish I still shared their optimism about the power of photography to inspire social change.

While I was there, I also had the opportunity to attend the National Press Photographers Association awards ceremony in Kansas City where I met photo editors from the major American newspapers and the Photographer of the Year award recipient. The attendees were press photographers who travelled the globe covering sporting events, war zones, and international politics for publications like the *New York Times* and *National Geographic* magazine. It was an eye-opening experience for a photography student fresh from the plains of Alberta.

Towards the end of the second term, I had a clear idea of what a career in photojournalism would be like, and I concluded that it wasn't for me. The competition for jobs at city newspapers was fierce, so a graduating photography student had to start out at a small-town weekly newspaper, building up the experience and portfolio necessary

to land a job at an urban daily newspaper. If I took that route, I would have no control over who or what I photographed, and a news corporation would own and control the use of my images. I had bigger dreams, so at the end of the second term, I left Kansas to pursue them.

I HEADED SOUTH once again in my battered Toyota, ending up on sun-drenched South Padre Island, a kilometre off the Gulf coast of Texas. I needed a job, and there were numerous restaurants serving the tourist trade, so I went looking for a position as a waiter. The fourth restaurant I applied at was Mr. Zee's, which was managed by an amiable husband-and-wife team. During the interview, they told me they needed a cook and asked if I had any experience. I had never worked in a restaurant, but I had cooked for my family since I was young. How hard could it be?, I reasoned. So I found myself living on the island cooking steaks and seafood platters.

The border was just thirty minutes away, and I started doing street photography in the border town of Matamoros, Mexico. I worked evenings at the restaurant and spent my days photographing in the poor neighbourhoods of Matamoros, doing my version of the Concerned Photographers' work. Looking back, it was clearly not a good idea for a young "Norte Americano" to go walking alone in the Mexican border-town barrios armed only with a camera. But someone up above must have been looking out for me, because I never had any problems during dozens of trips across the border.

At some point, I heard about the Zapotec Indigenous people of Mexico, who still lived in the traditional way, and I began to do research in the Brownsville Public Library. They lived in a rugged, mountainous area in the state of Oaxaca, at the southern tip of Mexico, next to Guatemala. Their population was about 350,000, and their language,

culture, and way of life were relatively untouched by modern society. So after three months of living on South Padre Island, I decided to travel there to take photographs. I parked my Toyota at a friend's house, crossed the Mexican border, and rode buses south until I reached Oaxaca, where I spent two months photographing in San Cristóbal de las Casas. One evening, while I was away from my rented room, my camera equipment was stolen, so I never made that trip into the mountains to visit the isolated Zapotec people. In hindsight, I consider that to be a good thing. Had I visited that isolated, mountainous region alone, I might not be here to write this account. I understand now that a naive twenty-three-year-old man from Canada, working alone and unsupported in the highlands of Oaxaca, Mexico, was an extremely dangerous situation.

After three months in Mexico, I returned to the United States to continue my training as a photographer. I knew a couple of people in

Dallas, Texas, from my time at the University of Kansas, so I left the tranquil Gulf Coast for the sprawling metropolis of Dallas. The local economy was flourishing in the 1980s, and there was a lot of corporate, advertising, and editorial work for photographers. After a few months of adjusting to the city and living hand to mouth, I was fortunate to land a job as a photographer's assistant – in the largest photography studio in the city. Greg Booth, a top corporate photographer, had a huge warehouse containing a dozen photography studios that employed ten photographers and twice as many assistants and support staff. Greg was very much in demand, constantly flying around the globe doing annual report photography for major corporations. He was rarely in the studio, and I worked there for six months before I met him for the first time. I was an assistant to Mark Bumgarner, who did product photography. I got the job purely on the strength of my portfolio, as I had no experience working with complicated studio lighting and the multiple-camera systems used by commercial photographers. But I was keen and good at learning on the job, and during the time I worked there I learned to use complex flash lighting systems and an array of cameras – from a 35mm Nikon up to large-format view cameras, which use large sheets of hand-loaded film.

In my spare time, I went to "Billy Jack" Jackson's gym to continue my kick-boxing training, a sport I had taken up in Kansas. Jackson was the best in the area. He was the American super welterweight champion and had a record of sixteen wins, no losses, and nine knockouts. He had a private gym in a rough neighbourhood in south Dallas, where he trained with a handful of other kick-boxers. I had never been in a boxing gym before, but I introduced myself, told Jackson that I wanted to learn more about kick-boxing, and asked if I could work out with them. They were friendly and said that I was welcome to join them.

facing

Matamoros Child, 1982
silver gelatin print, 11 × 14 in.

This is one of the images from my first photography series. I took the photographs in the low-income areas of the border town of Matamoros, Mexico.

There were no classes and no formal instruction; it was a lot like the carvers I worked with several years later – everybody did his own thing, and when I asked a question, someone gave me advice. I practised the punches and kicks I'd learned in Kansas, and as I watched the professionals work out, it was evident that they were in another league. After about an hour, they paired up, got into the ring, and started sparring. Billy's trainer handed me a pair of sixteen-ounce gloves and said, "You can spar with Billy." I was shocked at the suggestion of getting in the ring with him, and I replied that I was no match for him. I had never even been in a boxing ring. He smiled and said, "Don't worry, Billy has great control. He won't hurt you."

We tapped gloves, and I starting moving around and throwing a few hesitant punches. Billy threw a couple of punches and kicks that were obviously slowed down for my benefit. Then he threw a spinning heel kick. If done correctly, it is very powerful and impossible to see coming. Billy Jack's heel kick was perfectly executed and struck me on the side of my face, knocking me out cold. Being knocked out is an experience I'll never forget: one minute I was on my feet, then I was lying on my back, looking up at people who were staring down at me, and my first thought was, How did I get here? The rest is hazy, but I recall being helped to my feet and supported as I climbed out of the ring. And that was my first kick-boxing lesson in Texas.

My eyes immediately began to swell up, and by that evening both of them were solid black. One black eye will make people do a double take, but two black eyes – that's a conversation starter. But I was young, and being knocked out wasn't going to deter me. The next day, I went back, and Billy and the others seemed surprised to see me again. They found my raccoon eyes greatly amusing. Later, I realized that it was

a test or a rite of passage, and I became that crazy Canadian kid who Billy Jack knocked out. I stayed and trained with the champ and his crew for two years, and they shared their skills with me. All of them had black belts, professional fighting experience, and titles, whereas I only had youth and a desire to learn.

While I was in Dallas, I also continued to do documentary projects in my spare time. I spent two years photographing Freedman's Town in an area of the city known as State Thomas. Freedman's Town was a historic African American neighbourhood where former slaves had gathered after the Emancipation Proclamation of 1863. During the days of segregation, black entertainers such as Louis Armstrong and Ella Fitzgerald had stayed in the area's hotels when they performed in Dallas. The neighbourhood was on the edge of downtown and was being "gentrified." Long-time residents whose families had lived there for over 120 years were being pushed out by any means necessary to make way for expensive townhouses and trendy boutique shops. Established businesses found their taxes tripled overnight and their customers were moving away. I photographed the eclipse of

The Frontier Barber and Beauty Shop, 1984
silver gelatin print, 11 × 14 in.

This barber shop in Freedman's Town in Dallas, Texas, had long been a social meeting place in the community, and I often stopped by to chat and take photographs of the locals.

that historic neighbourhood. I was drawn to it because it had a sense of community, which I imagined was similar to life on a First Nations reserve. Later, when I was more familiar with life on reserves, I discovered this to be more or less true.

One day, I was walking down Thomas Street when an old man, what Indigenous people refer to as an elder, called to me from his doorstep and indicated that he wanted me to come over. He asked me to come into his house and explained that he needed my help to change a light bulb in his kitchen. Reaching the bulb required standing on a chair, which he couldn't do at his age. I changed the bulb for him, and then we had a long conversation, during which he told me about the history of the area and his days as a sergeant in the Marines. I was happy to hear

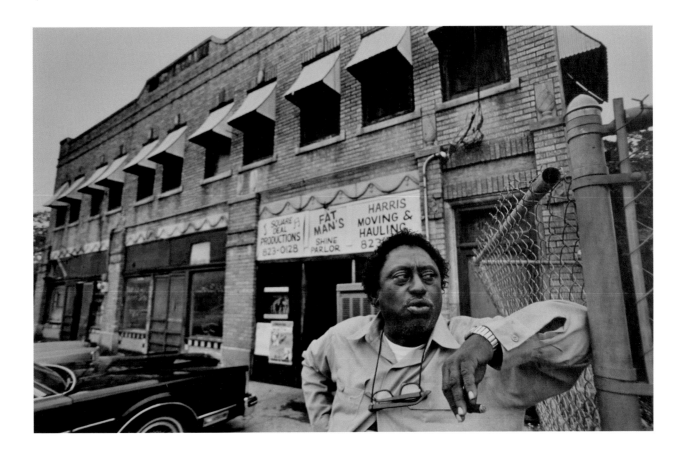

Fat Man, 1984
silver gelatin print, 11 × 14 in.

This man was the proprietor of a recording studio, shoeshine parlour, and moving company in Freedman's Town, 1984.

about the old days in the neighbourhood, and he was happy to have someone to talk to. I found his unassuming neighbourliness unlike anything I had known before: inviting a stranger to come into your home to assist an elder was a practice of a bygone era. I was pleased to help him out with that small task, and I went back to visit and photograph him many times. I called his portrait *The Proud Homeowner*, and it remains one of my favourite images. The photographs I took in Freedman's Town formed the basis of my first two solo exhibitions, first at the Still Light Gallery and then at the LTV Center, both in 1984.

I was drawn to another historic Dallas neighbourhood, Deep Ellum, a former light industrial area that was undergoing gentrification of a different kind – more positive and creative. Artists were renovating

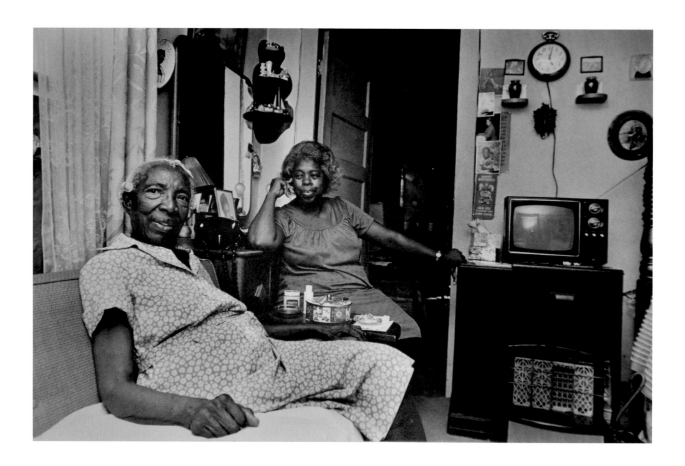

above

***Mrs. Lily B. Holloway and Her
Daughter, Myrtle,*** 1984
silver gelatin print, 11 × 14 in.

Mrs. Holloway was quite elderly and
had health problems, so her daughter
moved from Seattle to Freedman's
Town to care for her. I regularly visited
and photographed her, and that was my
first experience working with an elder.

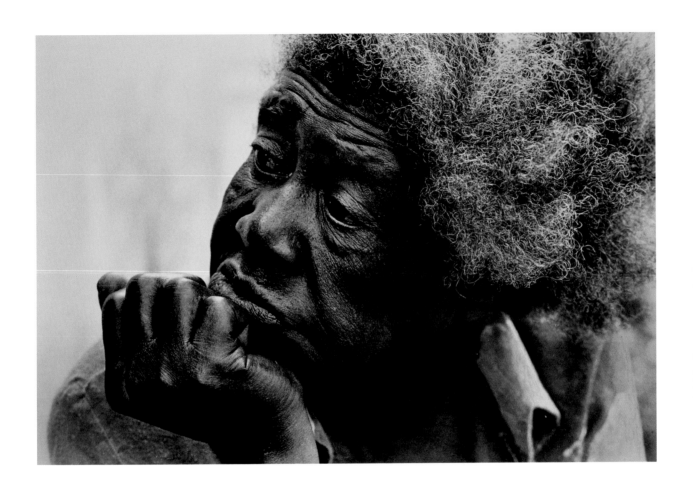

above

The Long-Time Resident, 1983
silver gelatin print, 11 × 14 in.

The people who lived in Freedman's Town were the descendants of former slaves who had gathered there after the Emancipation Proclamation to protect themselves. There was a feeling of community that is rare in inner cities today.

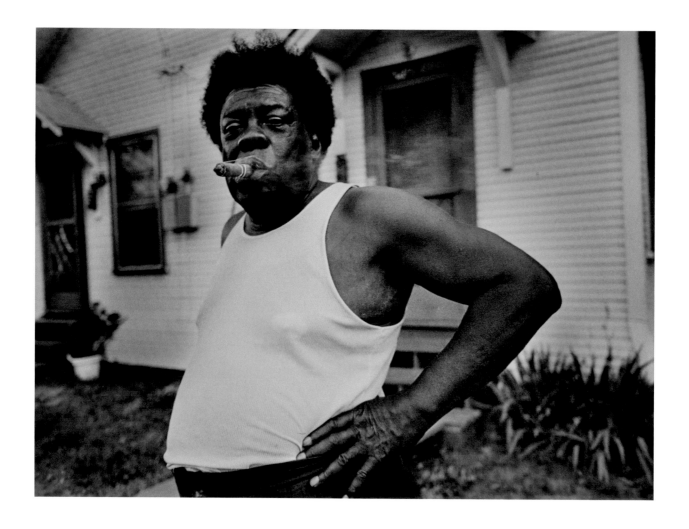

THE WAY HOME

decrepit warehouses and turning them into studios and artist-run galleries. I started doing portraits of the artists in their studios, incorporating their art and elements of their personal lives in the images. Continuing to work in black and white, I made sixteen-by-twenty-inch prints of each artist and invited the artist to augment the portraits in his or her individual artistic style. I had the energy of youth and was processing the film and making the prints by hand in a homemade darkroom. I came up with a unique approach to funding: I went to the companies developing the area and asked them to finance the project, which, surprisingly, they did. The results were eclectic, humorous, and sometimes inspired. Visiting those artists in their studios and getting to know them and their art taught me more than I can put into words. Some of them were up-and-coming young artists with youthful energy and splendid dreams, and others were established artists with years of experience. I learned a great deal about how artists live and how the art world works. I probably learned more from those twenty artists than I would have from doing a bachelor of fine arts degree at a university.

The exhibition of enhanced portraits opened at the Allen Street Gallery in September 1986. With twenty other artists participating and their friends and collectors in attendance, the opening night was a gala event. This was my third solo show, and the curator later told me that the gallery usually scheduled exhibitions two years in advance; because they thought my concept was unique, they made space for me in the schedule in just six months. I know now that galleries book shows years in advance, but at age twenty-six I was so naive that I just assumed I could show my work to a gallery and get an exhibition a few months later.

facing

The Proud Homeowner, 1984
silver gelatin print, 11 × 14 in.

I first met this man when he asked me into his home to help change a light bulb – an invitation that was typical of the sense of trust and neighbourliness that existed in Freedman's Town. I went back to visit him many times.

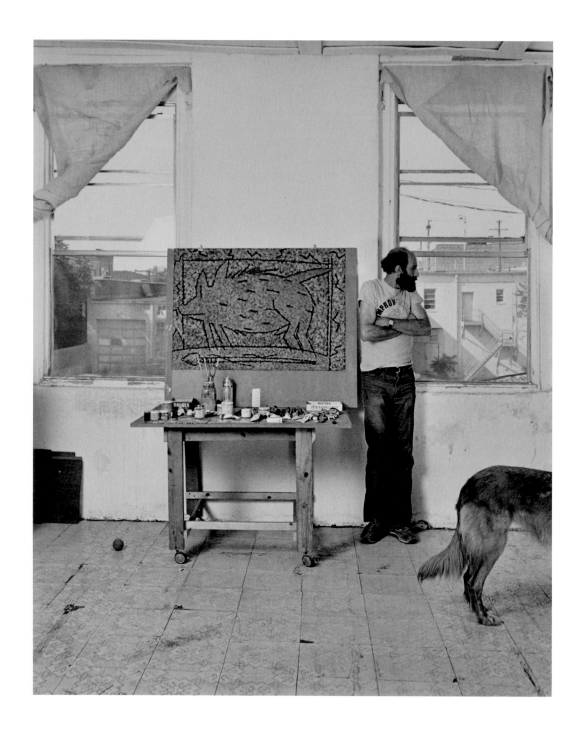

above

Deep Ellum Artists #1, 1985

silver gelatin print, watercolour, 20 × 16 in.

John Abrams in his studio.

above

***Deep Ellum Artists #2**, 1985*
silver gelatin print, 20 × 16 in.

Kip Lott in his studio.

THE BATTLE OF TRANSFORMER AND XATE'TSEN

One day, the Transformer came across the house of Xate'tsen, who, like himself, was a supernatural being. The Transformer was invited inside, and Xate'tsen gave him salmon to eat, but it was really meat of the *sisiutl* (the mythical sea serpent), and the Transformer's body became grossly contorted. Using his great powers, the Transformer overcame this and then transformed Xate'tsen into a stone. Xate'tsen soon made himself into a man again and then transmuted the Transformer into a boulder. But the Transformer's powers were too strong, and he immediately became a man again. Then he grabbed Xate'tsen, spun him around, and threw him high into the air, where he became fog. Xate'tsen used his mythical abilities to make himself into a man once again, and he in turn changed the Transformer into fog.

Then they changed each other into cranes, but with their powers they each changed themselves back to men. Xate'tsen said, "You have great powers, my friend, so let's test them. We'll go to my playground." Each of them wore belts of the sisiutl, which enhanced their supernatural abilities. They travelled in separate canoes and when they arrived Xate'tsen told the Transformer to go ashore to his playground but to be careful because it was slippery with the blood of those who had come before. The Transformer went ashore, and he appeared to slip on a loose rock, and his sisiutl belt came off. He fell backwards into his canoe, which Xate'tsen then tipped. The Transformer fell into the deep water and sank. Xate'tsen waited a long time for him to come to the surface, but he never did, and Xate'tsen believed he had finally beaten the Transformer.

Meanwhile, the Transformer had used his power to return to Xate'tsen's home, where he transformed his big house, his stored food, and his most valued possessions into stone. So, in the end, the Transformer had beaten Xate'tsen, who never discovered how he had done it.

I have had a number of exhibitions since those first ones in Dallas, and a few have been important to my career, but the exhibition that was a turning point in my life didn't include my own work. In 1986, the Modern Art Museum of Fort Worth, an hour's drive from Dallas, had an exhibition organized by the Museum of Modern Art titled *"Primitivism" in 20th Century Art: Affinity of the Tribal and the Modern*. Artworks by modernists such as Picasso and Mondrian were exhibited alongside art by "primitive" artists from Africa, Australia, and North America to illustrate how the modernists had been influenced by the art of the Indigenous people of the world. It was a large and impressive exhibition, bringing together a diverse array of work from all over the world, and I enjoyed wandering through the displays. But when I came to a case that contained a Northwest Coast Indigenous mask, the first I'd seen other than in photographs, I stopped. Dramatically lit and surrounded by deep shadows, it communicated with me at a visceral level. I could feel my connection to that mask as though it had an energy of its own that made me need to know more – what it represented, where it came from, and who had carved it. Those questions came into my mind, and I felt I already knew the answers. I suspected that the mask had been carved by one of my ancestors, and I studied it for a long time, waiting for it to release its mysteries to me. The label in the display case provided little information, but I couldn't shake the feeling that there was important symbolism in that mask, and I wanted to know more.

The exhibition catalogue included a colour photograph of the mask. I purchased it in the museum gift shop, and I've had it on my bookshelf ever since. For weeks afterward, I looked at that photograph every day, as though I could make it reveal its secrets through force of will. Years later, I learned that it was a mask of Tsegame, the Great Magician of the Red Cedar Bark, carved by my great-great-grandfather Charlie James.

But at the time, I didn't know this; I only had my intuition to access the symbolism of that powerful carving. I soon made up my mind that it was communicating to me that it was time to go home, that it was time to find my family and follow in my father's footsteps.

Inspired by Charlie James's Tsegame mask, the search for my family began. My mother had exchanged letters a few times over the years with my Aunt Cora Beddows, and she still had her address. Apprehensive, I wrote to my long-lost aunt, whom I hadn't seen since my infancy. I was pleasantly surprised when she wrote back. Her letter recounted memories of my father and the extended family still living in British Columbia.

My aunt's letter was my first contact with my father's family since the visit with my grandmother Ellen when I was three years old. Around the same time as my aunt's letter, my mother came across a book titled *The Totem Carvers: Charlie James, Ellen Neel, and Mungo Martin* and mailed a copy to me in Texas. Written by Phil Nuytten, a long-time friend of the family, it told the story of three of my ancestors who were traditional Kwakw̱aka'wakw artists. There were dozens of black-and-white photographs of them carving masks and totem poles, from 1900 through to the 1960s. My father, Dave Senior, was in a number of the images, which meant a lot to me because I'd only seen a handful of photographs of him. *The Totem Carvers* influenced my decision to return home. What home was and where it lay was becoming more distinct and tangible. I received more letters from my three aunts – Theresa, Pam, and Theo. Each one contained more crumbs of information that helped build a picture of our shared heritage.

I became preoccupied with the idea of leaving Dallas behind and returning home. I had a house, friends, and a career in Dallas, and it seemed an immense and daunting step to restart my life twenty-eight

hundred kilometres to the north, even though it was my birthplace. But, in April 1987, I packed up my life and moved back to Vancouver.

FOUR YEARS AFTER moving home, on a blistering August day, a FedEx truck pulled up in front of my studio in Nanaimo, British Columbia. The driver handed me an envelope and asked me to sign for it. I noted that the envelope, curiously, was from the Smithsonian Institution in Washington, DC. I knew the Smithsonian was a massive organization that had eleven museums on the National Mall, so I was surprised that it would be writing to me. I opened the envelope to find a single sheet of paper with "National Museum of the American Indian – Smithsonian Institution" emblazoned at the top. The letter informed me that the Smithsonian was opening a new museum in New York and wanted to commission me to do a series of photographic portraits of leading Native American artists, educators, and traditionalists. I called the curator to discuss the project, and a few days later the FedEx truck pulled up once again, this time to deliver a contract. It required me to travel to a dozen locations in the United States, to both reservations and cities, to produce twelve large-format photographic portraits.

Large-format photographs require a type of camera that uses sheets of four-by-five-inch film, which are loaded, one at time, into the back of the camera. The result is an extremely high-definition image that can be enlarged into a crisp, clear billboard-sized print. The camera itself looks like something from a 1920s movie. It's mounted on a tripod, and the photographer, covered by a black sheet, looks at the subject through a four-by-five-inch piece of ground glass – very old-school. It was unusual to use a large-format camera on location, and I had to purchase an oak-and-brass field camera from New York. This was before the internet, of course, and finding an unusual piece

Chief Joe Medicine Crow and I after the photography session at his home in Crow Agency, Montana, 1993. I am holding the large-format oak-and-brass camera I used on location.

of photography equipment required phone calls to several suppliers, waiting for a catalogue to arrive by mail, and then a phone call to place the order, which would arrive a week later. Arranging shooting dates with the subjects, and then booking the flights, rental cars, and hotels, took a solid week on the phone.

At last, the arrangements were made, my gear was packed, and the work could begin. The first destination was the Navajo Indian Reservation, where I was scheduled to photograph D.Y. Begay, an exceptional Navajo weaver. I flew into Gallup, New Mexico, picked up my rental car, and drove an hour and a half to the reservation. I was surprised to find that it was enormous – the largest reservation in the United States, comprising twenty-seven thousand square miles. When I had spoken to D.Y. on the phone, I had written down directions haphazardly, thinking that since it was a reservation everyone would know everyone else and that I could always ask someone for directions. As I sat in my car, I looked at my hastily scribbled directions – "turn left at the service station," "turn right at the big tree," and so on – and realized that they were totally inadequate.

I pulled into a convenience store. It was clean and well stocked, and it looked like a set from a 1950s movie. I felt like I had been transported back in time. In fact, I had moved forward: the clock on the wall indicated that it was 3:15 p.m., which didn't seem right because the clock in the rental car said 2:15. I asked the clerk if the clock was correct, and she said, with a smile, that it was, that daylight savings time was not recognized on the reservation. I recalled a quote attributed to an anonymous Indian chief, "Only a white man would believe you could cut a foot off the top of a blanket, sew it to the bottom, and have a longer blanket." This meant that I was already an hour late for my appointment. Off to a good start, I

thought. I bought a Coke and asked the clerk if she knew where I could find D.Y. Begay's house. She laughed and told me that the Begays were a really big family – there were hundreds of them – and that I would need more information than just her name.

I got back in the rental car, cranked the air conditioning to full, which was about half of what was required for the midday heat, and began my search anew. After an hour or so of driving in circles, I found myself driving down a single-lane gravel road that appeared to lead nowhere. Sure that I was lost again, I pressed on anyway until I came

to a small round house that I later learned was a *hogan*, a traditional Navajo house. D.Y. welcomed me and didn't mention that I was two hours late. I told her of my adventure, and when she told me the size of the extended Begay family, I realized that it was the same as the population of some First Nations reserves in Canada.

D.Y. made all her materials in the traditional way. She got her wool from sheep herders on the reservation, then washed, carded, and spun it herself. The dyes came from plants such as coreopsis (or tickseed), cosmos, and fennel and from insects such as cochineal that she harvested from the land herself. The manner in which she embraced her traditions, and the passionate way she spoke about the importance of sheep and wool to her people, were inspiring. For the Navajo, sheep and wool symbolize their connection to the land – in the same way that cedar and salmon do for First Nations people of the Northwest Coast, who traditionally used cedar wood, bark, and even the roots in scores of different ways. I realized that it is that common bond – our attachment to the land, symbolized through wool, cedar, or salmon – that makes Indigenous people unique. Wool, cedar, and salmon are symbols of an unending connection to a way of life, to a sense of place and traditions that link us to the ancestors and go back countless generations.

Like that moment in the Modern Art Museum of Fort Worth when Charlie James's Tsegame mask spoke to me, hearing D.Y. speak about her people triggered an epiphany, all the pieces coming together for a brief moment as thoughts, memories, and seemingly random bits of information fell into place to form a coherent idea. I thought of all the Indigenous people who had been separated from their families and communities at a young age, of people who had never found their

way home. I realized that this was the essence of what it means to be Indigenous: that unbroken, unbreakable connection with the traditional ways of the ancestors, which are symbolized by objects such as wool, cedar, and salmon. It's not the physical objects that contain that essence, for Indigenous people are not materialists in the modern sense of the word; rather, these objects symbolize a larger concept that we refer to as "traditional culture." The word *tradition* itself seems inadequate to contain the plethora of ideas and history that it's meant to represent – and, again, we arrive at the need for symbolism, with its limitless capacity to represent an abundance of information in an object or design.

I wondered if the Indigenous people in Vancouver's Downtown Eastside had lost their connection to the salmon and the cedar; were they searching for that lost part of themselves? I thought about my own circuitous road home, and I appreciated that you never know where a valuable piece of the puzzle will be waiting. The knowledge of my ancestors had been waiting for me in a museum in Texas – and, later, in the homes of British Columbia elders and in a hogan on the Navajo Reservation. All of this came to me in an instant, in the time it takes to articulate a sentence.

I looked down to see that D.Y. was handing me a piece of wool to feel. I touched it and was surprised at its soft and oily texture. The photography session continued, and I used the rugged landscape of the reservation as a background for D.Y.'s portrait.

The Smithsonian commission took me to a number of destinations in the United States, where I met some very learned and knowledgeable Native American people. I went to Anadarko, Oklahoma, to photograph a traditional dancer; to Santa Fe, New Mexico, to photograph

Abe Conklin on his property at
Anadarko, Oklahoma, 1992.

a writer; to Chicago, Illinois, to photograph a priest; and to the Crow
Agency, Montana, to photograph a hereditary chief. I met Native
Americans who had their feet in two worlds: they possessed tradition-
al knowledge while being recognized in their field at a national level,
to a degree sufficient to bring them to the attention of the Smithso-
nian Institution. As I made the portraits, it became apparent that I'd
been hired to photograph some of the leading Native American artists,
authors, educators, and traditional people of the time. It was my good
fortune that, in addition to completing a commission for an important
new museum, I had the honour of spending time with these learned
and accomplished Indigenous people, who were enlightening and
inspiring.

The opening of the National Museum of the American Indian in
the old Customs House in Manhattan's Financial District, in 1994, was
a day to remember. When I arrived, I was stunned to see that my pho-
tographic portraits had been printed eight feet high and encircled the
exhibition space. In the centre was displayed a selection of the best art
objects from the Smithsonian and Gustav Heye collections, along with
quotes about their function and history from the people I had photo-
graphed. My portraits were evidently intended to give the collection a
contemporary connection, with the result that my photographs occu-
pied a quarter of the exhibition space. Underneath each portrait was a
text panel with the person's name and tribal affiliation. To my dismay,
there was no photography credit anywhere in the exhibition. But a
number of the people I had photographed were there, and seeing them
again and hearing their responses to my portraits was wonderful. I
soon forgot my disappointment.

 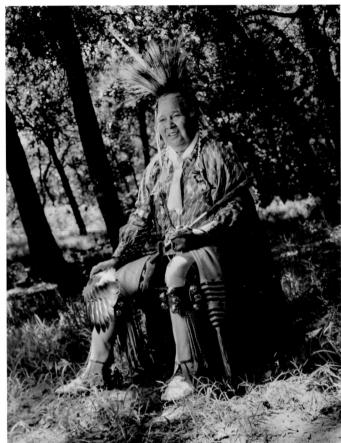

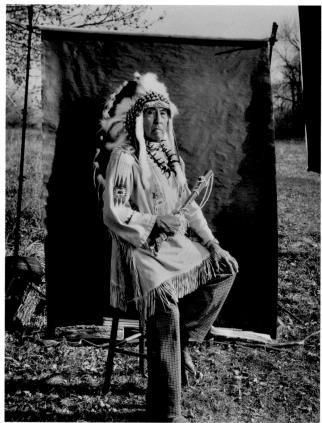

THE WAY HOME

ONCE IN A GREAT WHILE, the phone rings, and it's a call that will influence your life for years to come. One morning, I was hand engraving a bracelet in my North Vancouver studio when the phone rang. The call was from an exhibition design firm in New York City, Mike Hanke Design. Mike's assistant told me they were interested in having me do photography for a new Native American museum being opened by the Mashantucket Pequot. I was told that the project would be a large commission. I had never heard of the Mashantucket Pequot Tribe or the design firm, so I was dubious and asked if they knew what such a project would cost and if they had a budget in place for the work. The assistant replied that the tribe had funding for the museum and that they owned a casino.

Mike's assistant asked me to submit a quotation and my photography portfolio. This was before every business had a website, so I packed up my portfolio and had it delivered to New York. I knew I was the only Canadian being considered and that I was competing with several American photographers, including one from *National Geographic*, so I wasn't optimistic about my chances. But a week later, Mike called me in person to tell me that the museum selection committee had liked my portfolio and would be sending me a contract. I almost dropped the phone on the floor before I composed myself and told Mike that I looked forward to working with him.

I remember the first time I saw the reservation, which is located in Ledyard, Connecticut, a short drive from the cities of New York, Boston, and Providence. Driving along a winding, two-lane road that cuts through the picturesque, rolling hills of the New England countryside, I came over a rise and saw an amazing sight in the distance: a cluster of high-rise buildings erupting into the skyline. They belonged

facing
Chief Joe Medicine Crow at his home at the Crow Agency in Montana, 1992.

to the Foxwoods Resort Casino, the jewel of the Mashantucket Pequot
empire. A miniature Las Vegas in the Connecticut countryside, the
resort was surrounded by family farms and small towns; it was a gam-
ing paradise in a backwoods setting.

I drove to the museum building site and located the temporary
offices, housed in a series of forty-foot trailers. The museum's director,
Theresa Bell, and a score of consultants were implementing a plan to
build a 65,000-square-foot museum that would rival the museums
on the National Mall in Washington, DC. When completed, the muse-
um would be the largest ever built by a Native American tribe. The
informal atmosphere created by the temporary offices in the trailers
encouraged staff and contractors to socialize in a relaxed way, and on
Friday afternoons everyone met at the Two Trees Inn for coffee and
pastries and to chat about the week's activities. That was where I first
learned about the modest beginnings of the Pequot empire, which had
evolved from a number of small businesses, including a modest bingo
operation, maple syrup factory, and pig farm, into a billion-dollar-a-
year gaming operation that included a hotel and a 344,000-square-
foot casino and entertainment complex that provided local residents
with ten thousand jobs. Foxwoods was one of the largest casinos in the
world and by far the largest owned by a Native American tribe.

I did two exhibitions for the Mashantucket Pequot Museum and
Research Center: *A Portrait of the Mashantucket Pequot* and *The Mashan-
tucket Pequot Tribal Nation Today*. I spent several months working on
those exhibitions, and Connecticut became like a second home to me.
A Portrait of the Mashantucket Pequot was designed to be a permanent
exhibition. Originally, it consisted of forty portraits, and I returned
several times over the next twelve years to do more, which were

switched with the original photographs to refresh the exhibition. The idea was to show the tribal members as contemporary, modern-day individuals, challenging mainstream society's stereotypical view of Native Americans as vestiges of the past. The other exhibition, *The Mashantucket Pequot Tribal Nation Today*, included a selection of colour photographs of life on the reservation. Those two exhibitions form one of the most in-depth photography projects ever done with a Native American tribe.

The scope of the projects required a lot of organization, so I scheduled the appointments in advance from Vancouver, using a list of tribal members provided by the museum. The subjects of the portraits were always surprised when I showed up with a carload of equipment and then set up an on-site photography studio in their homes. Because the photos would be printed over a metre in height and because the museum wanted black-and-white film for their archives, I used studio lighting and my classic large-format, oak-and-brass camera. It was a slow and exacting process, which few on the reservation had experienced before.

I met some delightful people, and the elders had wonderful stories to tell. Through these two projects, I became familiar with the people and their community as few others from outside the reservation ever

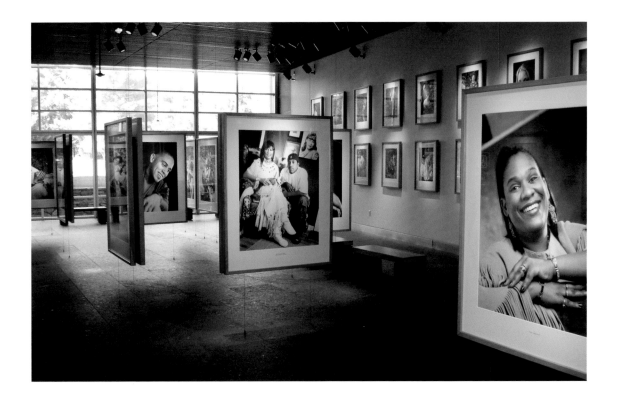

had before. I've spent more time on the reservation than I have on my own reserve, and I got to know the people and appreciate their circumstances. As one of the wealthiest tribes in America, the Mashantucket Pequot have been written about extensively, but tribal members seldom give interviews. I had the pleasure of getting to know the people and their stories of how their tribe came back from the brink. (At the turn of the twentieth century, there were only eleven Pequot families living on the reservation, but by 2005 the tribe had grown to 785 members. The survival of the Mashantucket Pequot tribe is a real success story.) One of the most charming and knowledgeable individuals I met was Laughing Woman, whom I photographed along with her mother. She was a warm and welcoming person, and she told me a lot about how the tribe had almost disappeared before its resurgence. The reservation is no longer large enough to house the entire membership, although the Pequot homes were usually within a twenty-minute drive of the reservation, and I enjoyed driving the picturesque country roads to my appointments. New England is beautiful country, and it was marvelous to get to know its quaint diners, winding backroads, and gracious people.

After all the photography was finished, I looked forward to the completion of the museum and seeing my photographs installed in the permanent exhibition space. I was especially looking forward to the opening and hearing the responses of the people I had photographed. The months went by with no word from the museum, and then one day I came across a copy of *Indian Country Today* that had a story about the gala opening of the Mashantucket Pequot Museum – two weeks before. Evidently, in the rush to get everything ready, no one had thought to invite the photographer to the opening.

Later, when I saw the exhibition and the room that had been built to house my portraits, I found that Terry, Mike, and the museum team had built the ideal setting for exhibiting and viewing photographs. It was a large, rectangular space with white walls, stone floors, and a high, warm wood ceiling. On one end there was an expanse of windows that allowed a diffused, natural light to illuminate the images. I have gone back many times to walk among the portraits and remember the time I spent with the Pequot people and the stories and jokes they shared with me. When I look at my photographs, displayed so wonderfully in the largest tribal museum in America, I am thankful that the Creator gave me skills that allowed me to portray the Pequot people honestly and, I hope, eloquently.

BECAUSE OF MY WORK for the Mashantucket Pequot Museum, the director of the Pequot Powwow Committee, Kenny Reels, asked me to photograph Schemitzun, the Annual Feast of Green Corn and Dance Powwow, which is hosted by the tribe every August. For three years, starting in 1995, I documented in photographs the Super Bowl of the powwow world, the largest and most prominent powwow in America. The best Native American drum groups, dancers, entertainers,

facing
The exhibition space at the Mashantucket Pequot Museum and Research Center.

facing top

Derek Davis (Hopi-Choctaw) during
the Hoop Dance competition at the
Schemitzun Powwow, Mashantucket
Pequot reservation, Connecticut, 1996.

facing bottom

The winner of the Men's Grass Dance
competition at the Schemitzun
Powwow, Mashantucket Pequot
reservation, Connecticut, 1996.

and artists attended the grand event, which was unlike anything ever seen in Indian country at the time. The first year, my Vancouver travel agent booked me into a hotel forty-five minutes from the powwow grounds, which was too far to drive every day when I was working twelve hours a day. When I mentioned this to someone from the public relations department, she offered me a room that had been set aside for a Washington politician who hadn't shown up. It turned out to be a high-roller suite, a deluxe apartment with a private bar, sitting room, and bedroom. The bathroom alone was the size of a typical hotel room and had three telephones. All of the rooms on that floor were for big-stakes gamblers, and there was a complimentary deluxe buffet and full bar open twenty-four hours a day. So, after photographing Native American drum groups and dancers at the powwow grounds all day, I relaxed and ate Alaskan king crab legs at the high-roller buffet.

Over the years that I photographed the powwow, I met an amazing assortment of people from tribes across North America. One year, I photographed and interviewed Russell Means, arguably one of the most prominent Native Americans of his time. An Oglala Lakota from the Pine Ridge Indian Reservation, he had been an activist with the American Indian Movement, taking part in the occupation of Alcatraz in 1969 and of Wounded Knee in 1973. Later, he became well known as an actor and spokesman on Native American rights and co-starred in a number of Hollywood movies. When I interviewed him, he was an elder who had lived an unusual life; he'd learned a lot along the way, and he was generous with his knowledge. I was blessed to have had a lively one-on-one interview with such an extraordinary and distinguished leader. Having the opportunity to spend time with such incredible people is without doubt the best part of being a professional photographer.

EAGLE FROM THE SKY WORLD

In ancient times, two eagles and their children flew down from the sky world, built a house, and lived in the land of the Kwakwa̲ka'wakw (northern Vancouver Island). One day, the eldest son, Le-la-ka, took his dugout canoe out hunting for seals. About midday, he saw some seals resting on a small island, and he paddled closer; silently and skillfully, he threw his harpoon at the largest one, and it struck and held fast. The seal seemed to be unaffected by the wound and jumped into the ocean and swam away, towing the canoe behind him. When they were far out to sea, the seal transformed into a giant octopus and dove beneath the waves, pulling the canoe under. Le-la-ka drowned. Although he died as a man, he was immediately reborn as an eagle, and he burst through the surface of the ocean and flew up into the sky.

Le-la-ka's parents missed him when he didn't return, and thinking that he must have died at sea, they mourned his passing. One day, Le-la-ka flew into the village with the morning sun at his back, and his parents recognized him at once. He had a box with him that contained flutes that sounded like the call of eagles when blown, and he had a transformation mask that had a man on the inside and an eagle on the outside. Le-la-ka's parents hosted a feast to celebrate his return, and he danced the transformation mask, re-enacting his adventure at sea. He had a supernatural bowl, carved in the shape of an octopus, that produced endless quantities of eulachon (fish) oil, and he gave a feast that was talked about for generations.

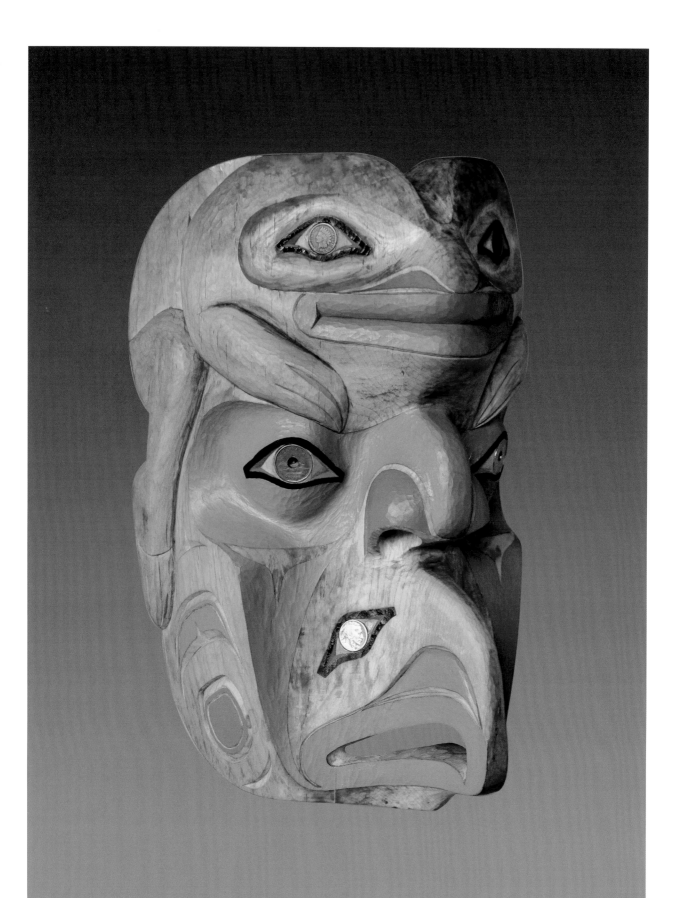

3/ MASKS
HOMECOMING

KOLUS COMES DOWN FROM THE SKY WORLD

In ancient times, a Kolus liked to come down from the sky world to rest at a lake that the local people called Sitting Alone Lake. Over time, he decided to live there, so he took off his Kolus mask and transformed into a man. He took the name Chief Surpassing and built a big house near the lake. The lake fed into a river, where he built a salmon weir to catch fish to feed himself. He was alone and longed for companionship, so he took two alder trees and carved the shape of two men and two women in the bark. Then he said, "Now you will become real people," and he returned to his big house. In the morning, he returned to find living men and women stuck to the alder trees. He pulled them off and they became his family.

He showed them how to roll stones together in the river and make themselves a weir to trap salmon. Then they cut down red cedar trees, and he helped them make big houses close to his own, and now they had a village. The next day, he purified himself by bathing in a mountain stream, and then he went hunting for food for the village. When he returned, he had many geese and deer, and he showed the people how to make the skins into clothing. Eventually, the Kolus longed to see his home, so he put on his mask, transformed himself into a bird again, and flew back to the sky world.

facing
Tsegame the Great Magician
mask, 2017
alder wood, acrylic paint, and Canadian and American coins, 17 × 12 × 10 in.

Tsegame, the Great Magician of the Red Cedar Bark, had great powers, including the ability to transform into animals. On his head is the frog and his mouth is the Kolus (Thunderbird), with the wings on his cheeks, which represents the powers that were given to him.

Wayne Alfred, working on a totem pole in Vancouver. I apprenticed with him for two years, starting in 1987, which laid a strong foundation in traditional Kwakw<u>aka</u>'wakw art.

Beau Dick, an important mentor of mine, carving a totem pole in 1987 that now stands in Stanley Park, Vancouver.

The people continued to live by Sitting Alone Lake, and with the knowledge they had gained from Kolus they prospered. Today, the descendants of Chief Surpassing use the Kolus mask as their crest and perform the goose dance in their feasts.

In 1987, after an absence of twenty-five years, I returned to Vancouver and moved into a house in the city's Mount Pleasant neighbourhood, two blocks from City Hall, on Cambie Street. I was still doing the street photography that I'd been doing in Mexico and Dallas, and I would take my Nikon camera and walk the streets, photographing the people I met. My experiences in Mexico and Dallas had taught me to work with the public and to improvise with a camera. One day, I was walking the neighbourhood taking photographs when I came across a totem pole that was being carved just a few blocks from my house. It was a Sunday, and no one was working; I resolved to return the next day. Finding carvers working there the next afternoon, I introduced myself and asked if I could photograph them. The carvers were Beau Dick, Wayne Alfred, and Lyle Wilson, who would later be recognized as three of the best artists of their generation. Lyle was Haisla, and Beau and Wayne were Kwakw<u>aka</u>'wakw from Alert Bay, where my family had roots. They referred to me as "Ellen Neel's grandson," and they were happy to let me take photographs. After hanging around the carving site for a couple of weeks, I expressed an interest in learning to carve, and they agreed to help me get started.

Whether by chance or destiny, within two weeks of returning to Vancouver, I was carving. My first carving was a Thunderbird mask. The totem poles in Stanley Park by Grandpa Charlie and Grandma Ellen

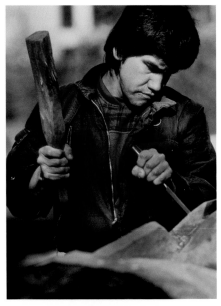

both had a Thunderbird on top, and I knew that was the main crest of my family. There was a lot of wood left over from Beau's totem pole log, and with his assistance I chopped out a block of cedar and set to work.

At that time, I was working to establish my photography business in Vancouver, so I did photography in the mornings and evenings, and I carved in the afternoons. The carvers used a teaching method that has been in use for many generations. They carved a small section on one side of my mask, which I would have to match on the other side. It was a good method that I found quite challenging in the beginning. With their expertise, they could carve an area in two minutes that would take me hours to achieve something similar.

Our old carving site is now the City Square Mall, at Cambie and 12th Avenue. The food court sits where our carving trailer used to be. Those were memorable days. I didn't yet have the skills to help with the totem pole, which now stands in Stanley Park, but I showed up every afternoon diligently and learned carving and Kwakwaka'wakw culture from the masters. A totem pole in progress is always a destination for the First Nations community, and other carvers often came by to visit and sometimes to block out a piece of wood for a mask. I got to meet carvers from a number of tribal nations, including Russell Smith (Kwakwaka'wakw), Joe Peters (Kwakwaka'wakw), Isaac Tait (Nisga'a), and Ron Telek (Nisga'a), all of whom have returned to the ancestors. Russell was quite knowledgeable about Kwakwaka'wakw culture and an admirer of Grandpa Charlie's work, and he was happy to share his knowledge with me.

Vancouver had hosted Expo 86 the year before, and Northwest Coast Indigenous art had been discovered by an international audience, so the market was booming and there was an unquenchable

appetite for quality carvings. The guys worked long hours, and they usually sold a mask every week. It was a rare time, with an endless supply of old-growth cedar, galleries that always wanted carvings, and a pool of talented traditional artists willing to share their knowledge. It wasn't until many years later that I appreciated how rare it is for an apprentice to have access to a group of such knowledgeable artists. I learned a great deal by watching and listening to Beau, who, at that time, was already a master of the wood, carving with a carefree ease and teaching with a lead-by-example approach. Wayne's approach was thoughtful and methodical, and he was patient and generous with his time and knew a great deal about traditional Kwakwaka'wakw culture as well as woodcarving. In the years since then, I've watched young carvers struggle to learn fundamental skills and gain knowledge of our traditions, and I am reminded of how Beau, Wayne, and the others helped me learn the traditional skills.

THAT SAME YEAR, I made my first visit to Alert Bay, an exciting and overwhelming experience. After being away from the BC coast and my father's people for my entire life, "the Bay" had taken on mythical proportions in my mind. I knew that my Uncle Bob, my father's younger brother, still lived there. He had long ago given up on living in Vancouver and had returned to the village where Grandma Ellen had been born and raised. He made hand-engraved jewellery for the local Kwakwaka'wakw people. I'd been given his phone number by my Aunt Cora, and I called him from Vancouver. I remember his shock when he answered the phone and I told him that I was his twenty-seven-year-old nephew and wanted to visit. He hadn't seen me since I was an infant, so he was surprised to hear from me and invited me to visit him.

It was a long trip. Getting to Alert Bay from Vancouver involved two ferries and required seven hours of driving. I recall seeing picturesque Cormorant Island for the first time as the ferry crossed to Alert Bay from Port McNeil. The municipal town is on the east side of the island, and the Kwakw<u>aka</u>'wakw village is to the west, with the ferry wharf in the middle. Visiting the place where my father's family had their roots made me feel both excited and apprehensive. Grandma Ellen was born there in 1916, and my father would be born in Vancouver twenty-one years later – the first generation of our family to grow up *off reserve*. My uncle welcomed me into his home in the village, where he lived with his wife, Gootsa. Uncle Bob prepared a meal of smoked salmon, herring eggs, and eulachon oil, which was delicious – my first taste of traditional Kwakw<u>aka</u>'wakw food.

Alert Bay is well known for its Indigenous art, and I made my way to the waterfront to visit the U'mista Cultural Centre. Kwakw<u>aka</u>'wakw-owned and -operated, the centre houses many masks and potlatch regalia from the turn of the twentieth century, masks carved by old-time masters such as Bob Harris, Charlie James, and Willie Seaweed. It was a surreal experience, like a dream coming to life, to see the cedar masks and dance regalia by the old-time master carvers – like the ones depicted in my father's paintings – for the first time.

Beside the museum was the building that was formerly Saint Michael's Indian Residential School, which my grandmother Ellen and many other Kwakw<u>aka</u>'wakw children had been forced to attend. As I gazed at the aging red-brick building, I tried to imagine what it must have been like for my grandmother to have been taken from her parents and forced to attend school in an abusive institutional environment.

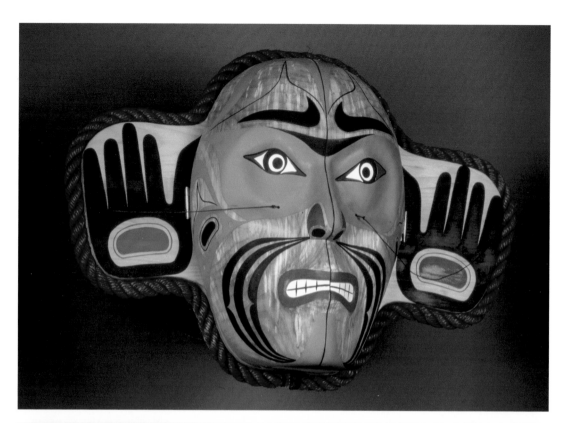

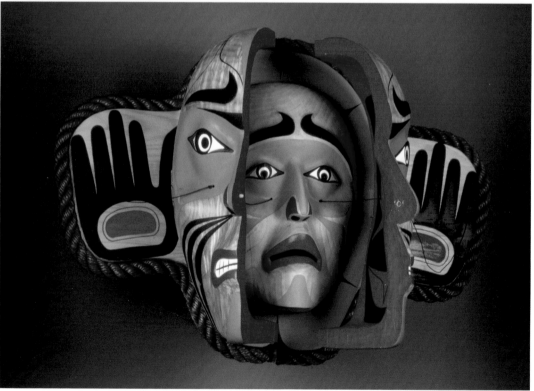

THE WAY HOME

From there, I walked along the waterfront to the graveyard. Its memorial totem poles are well known and appear in innumerable books, magazines, and tourist brochures. When I visited, a dozen or so totem poles stood facing the ocean in various stages of decay. The tradition is to allow memorial poles to waste away and then return to the earth. Their aged condition gives them a sense of history.

Walking through the graveyard, I spent a lot of time studying two totem poles by my great-great-grandfather Charlie James, which were still in reasonably good condition, despite years of being exposed to the elements. When I placed my hand on the cracked and well-worn cedar of his totem poles, I imagined that Grandpa Charlie's hands had touched that same spot many years ago. Touching the wood gave me a visceral connection to another time and to an ancestor who had passed on so many years before. Since then, I have seen a number of Grandpa Charlie's carvings and totem poles, and every time I have intuited some essence of the man in his art. But that day, in the graveyard at Alert Bay, I sensed that he was nearby, and I was grateful to have received the message encoded in his mask in that Texas museum. It was like Mouse Woman had come with a message from the spirit world, leading me to Alert Bay. I felt Grandpa Charlie watching me that day, and I was sure he was glad that I'd found my way home.

NEL-PÉ THE HUNTER

At Place of Loons, a chief had a son, Nel-pé, who was a skilful hunter. Early one morning, Nel-pé prepared his canoe for hunting. He had a beautiful cedar dugout canoe that was known to be the fastest among all his people. He scorched the bottom with fire and rubbed it with dogfish skin, which is rough like sandpaper, making the cedar perfectly smooth so it would glide

facing

Frightened Child Transforming into Angry Teen mask, 1999
alder wood, paint, and cedar bark,
16 × 28 × 10 in.

The outer mask portrays an angry and bitter teen, that, when opened, reveals the wounded child within; symbolizing the effects of early childhood trauma, which scars the victim emotionally for many years, possibly for life. When the mask is danced, the teen mask is seen first and then is opened to reveal the frightened child within.

silently through the water. Then he placed his yew-wood harpoon, hunting gear, and spare paddles in his canoe and paddled away from the village to hunt for seals.

Days passed, and Nel-pé didn't return, so his father went out in his own canoe to search for him. For days he searched in vain, until finally he found his son's harpoon and the bentwood box that had held his hunting gear. He assumed that his son was dead.

But Nel-pé was not dead. He'd been taken to the undersea world, where he visited Lord Komokwa, Master of the Undersea Realm. Komokwa greatly admired the fine canoe from the world above the waves, so Nel-pé gave it to him. In return, Komokwa gave him a supernatural spear to hunt seals and even whales. Komokwa was very generous and gave him other gifts: a name, Copper in the House; a dance mask of Dzun-o-kwa; several coppers; three feast bowls that would never empty of food; and a tiny cedar big house.

After staying with Komokwa for two days, Nel-pé returned to his village to find that he had been away for four years. After greeting his father and mother, he bade them to come outside, gently placed the tiny house on the rocky ground and stepped back, telling the people who had gathered to make room. Before their eyes, the house began to grow, slowly at first and then gaining speed, until it was larger than any house in the village. Nel-pé invited the people inside and feasted them with the magical feast bowls that supplied an endless amount of fish oil, spring salmon, and whale meat. When everyone was full and content, he brought out the mask and coppers that Komokwa had given him and showed the people his treasures and the dances that he had seen in the undersea realm. He became known as Copper in the House, and he became a respected and generous man.

For several years after my return, I was hungry for knowledge, and I wanted to make up for the time I had lost while wandering the world. I learned that the Smithsonian offered a Community Scholar Grant, which gave Indigenous people from Canada and the United States an opportunity to study its extensive collection of Native American artifacts. In 1992, I applied for and, to my surprise, was accepted as a Smithsonian Institution Community Scholar. I was scheduled to spend three weeks in New York, Washington, and Maryland.

At that time, a major part of the Smithsonian's collection was being relocated from New York to a state-of-the-art facility in Maryland, just outside of Washington, but I was fortunate to study the Smithsonian's Gustave Heye collection in its original location in the Bronx. Heye, a man of significant means, is said to have stopped working on Wall Street to pursue his passion for collecting Native American artifacts full-time. He built a collection of over 800,000 Native American items, the largest collection ever gathered by a single person, and opened the Museum of the American Indian in 1916, where he served as director until 1956. The collection was transferred to the Smithsonian's National Museum of the American Indian in 1989, creating one of the largest collections of North American Indigenous art and artifacts in the world.

Evidently an extremely energetic and well-organized man, Heye wrote the acquisition notes himself on five-by-seven-inch cards, which were stored in a card catalogue system – the database of the period. I studied his meticulously handwritten note cards, some with lengthy descriptions of the items collected, while researching thousands of artifacts. Wearing white cotton gloves, which were necessary because the artifacts had been treated with arsenic to protect the wood from

insects at the time of collection, I turned them over in my hands, noting how they were made and assembled and what materials were used. I don't know how many Indigenous people have held those precious objects since they were collected over a hundred years ago, but I know that it isn't many. Those treasures of Indigenous history had been stored in an antiquated facility in the Bronx for many decades, and I felt like I had stepped back in time as I worked my way along the rows of items, referring to Heye's handwritten cards, making notes, and taking photographs. I searched through chaotic rows of historical objects in the hope of finding treasures in the same condition as they had been when the eccentric collector returned with them from his field trips.

Like most people, I'd seen photographs of carvings by the old masters from the late 1800s in books, and the work was awe-inspiring. But holding the carvings in my hands was an experience beyond words; it was like holding history, physically, in my hands, and I will never forget it. I have held masks that were a hundred and fifty years old, felt the texture of the knife marks on the wood, saw the wear in the paint from years of handling, and ran my hands over glossy fur and natural hair. It was extraordinary, a rare privilege. In addition to discovering Charlie James's *Supernatural Halibut* mask, I also found a talking stick that had been carved by him but remained unattributed.

I was lucky that I had the opportunity to study the collection in its original state, before it was moved into the Smithsonian's modern, hyper-organized, and digitized storage facility in Suitlan. The sheer size of the Smithsonian's new facility for the National Museum of the American Indian collection is overwhelming. Each object, row, storage cabinet, and shelf is assigned a number and barcode, and that information is compiled in a database. The Heye collection is now stored in

a warehouse the size of several football fields, and the artifacts rest in row after row of metal cabinets, where they are safe and lifeless.

To my surprise, the Smithsonian had appointed not an intern or a grad student but a scholar with a PhD to work with me and help me access the collection. With his assistance I worked my way along the endless rows, unlocking metal doors to find ceremonial objects and carvings by long-deceased artists. The facility contains some of the earliest pieces of Native American art still in existence. Many were precious treasures that hadn't been seen by more than a handful of people in over a century. It took me a solid week to study all the pieces I wanted to see.

Some of them were truly amazing – I held in my hands some of the best creations by the top artists of the period, in essence, the finest Northwest Coast Indigenous carvings that exist. They represented so much history that they seemed to vibrate with a spiritual dynamism. As I held those ancient ceremonial objects, I sensed that their power had been diminished by many years of storage in an austere and foreign environment, but there was still a trace of the preternatural energy that had once flowed through them. They had been created in a time before the modern world, before jet planes, the internet, or modern medicine. Those sacred objects told the stories of heroes and otherworldly creatures from the ancient stories. The masks had been danced in fire-lit big houses, the cedar boxes had stored family possessions, and the paddles had once been used in dugout canoes by hunters seeking to feed their families. The history they contained was evident in their patina and well-worn edges, which underscored their importance as artifacts from another age. The texture of the feathers, the scent of cedar, and the feel of leather from more than a century ago spoke to me in a language beyond words. The smell, texture, and form

Killerwhale **mask**, 1994

alder wood, paint, cedar bark, feathers, copper, gold, silver, and operculum shells, 30 × 12 × 8 in.

There once was a young boy who, while out on the ocean in a canoe, was taken down to the village of the Killerwhales, where he married the chief's daughter. Eventually, he became homesick and was given many supernatural gifts to take home with him.

of those ceremonial objects changed my understanding of Northwest Coast Indigenous art and left an indelible impression on my psyche that influences and informs my art to this day. You may be thinking, "Tell me more," but it is not something to be communicated in words. For example, if someone described meditation, you may want to know more, but his or her reply would be, "There is not more to tell in words. You have to meditate if you want to know more."

I had a similar experience when I visited the American Museum of Natural History. The museum, one of the largest in the world, is on the Upper West Side of Manhattan, across the street from Central Park. Two months before my trip, I had written to the museum, requesting access to its collection of Northwest Coast art, which is one of the finest to be found and houses many of the early masterpieces. One of the most famous pieces is the massive *Great Canoe*, as the museum refers to it, which is displayed prominently in the main floor entrance. Carved from a single cedar log that is approximately seven hundred years old, it is an incredible sixty-three feet long, with sides so high that when you stand beside it you can't see over the gunnels. When you see it for the first time, it's hard to believe that such a finely crafted and enormous vessel could have come from a single cedar tree.

The collection also houses an especially fine chief's headdress, one of the most amazing things I have ever touched. A chief's headdress has a carved wood frontlet that features a face or multiple faces and is typically inlaid with abalone shell around the border. Traditionally, the frontlet was attached to a white headdress made from swan skin, with ermine skins trailing behind and sea lion whiskers protruding above, which would sway rhythmically with the dancer's movements. Chief's frontlet headdresses are still in use today – I have seen many and danced with a few of them, and I own one myself. Ermine skins

are still available, and I once had some sea lion whiskers. But I have only once seen a headdress made in the old way, with the down left on the swan skin – in the American Museum of Natural History. When I touched it, I was shocked: it was the softest thing I have ever felt, like touching clouds. It was a relic from another time, when the ancestors were more closely linked with the animal world.

For days on end, I pored over hundreds of artifacts, studying the most interesting ones in detail. Some of the secrets of those long-dead master carvers were there in the wood: their subtle techniques, how the cuts were made, the way the masks were rigged so that articulated pieces could be moved by the dancers, and the way colour and pigments were used. The masks, rattles, and bentwood boxes carved by the ancestors contained clues and information that have influenced my work ever since. Every Northwest Coast artist should have the opportunity to view those early carvings; it is like taking a class with the masters who have gone home to the ancestors.

When an experienced Indigenous artist studies a carving, he sees something very different from the casual observer. A carver sees the "cuts" or the steps that the master used to define the planes, angles, and shape of the wood. A skilled carver can look at an old mask, or even a photograph of it, and reconstruct the steps taken to produce it. Many

times, I saw Beau Dick or Wayne Alfred look at a photograph of a mask from the 1800s and then carve a piece that was the spitting image of the original. When I studied the carvings of the virtuosos of the 1800s, I not only studied the objects themselves but also visualized the process of creating them. I imagined each artifact in my hands as a block of wood and tried to determine the steps required to create such a masterpiece. I photographed many of the pieces in the American Museum of Natural History, and I sometimes still refer to those images when I am searching for inspiration.

After three weeks of research in New York, Washington, and Maryland, I flew home with copious notes, many photographs, and my mind overwhelmed with information gleaned from handling hundreds of pieces of ancient art. In the following years, I continued my research, studying numerous collections, including those at the British Museum, the Peabody Museum, the Field Museum of Natural History, the Canadian Museum of Civilization, the Seattle Art Museum, and the Burke Museum of Natural History and Culture. Closer to home, I also studied collections that contain more recently collected but no less striking artifacts, including those at the Vancouver Museum and at the University of British Columbia's Museum of Anthropology. Researching the artwork of the early masters was an attempt to make up for the decades lost before I found my way home. As I handled those age-old carvings, I felt a little more of that lost heritage being transferred to me, which I hoped would make up for the teachings I had missed in my childhood. Seeing the many characters depicted in those early carvings, and knowing that they were inspired by the ancient stories, heightened my curiosity, and I wanted to know more about the characters, themes, and knowledge contained in the tales that had been handed down by the ancestors. Since then, I have

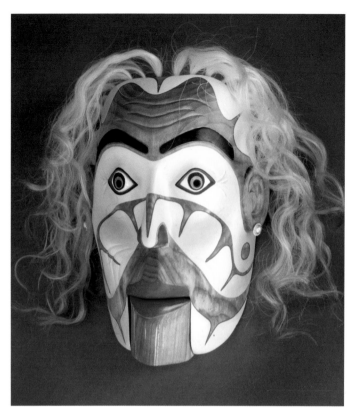

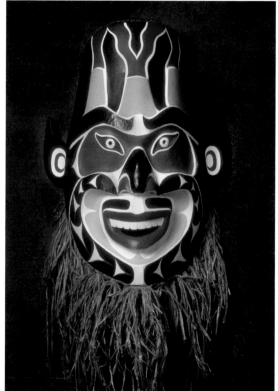

Aging Trophy Wife mask, 1998
alder wood, paint, cow tail,
and earrings, 16 × 11 × 7 in.

In the 1990s, I often exhibited in
Phoenix, Arizona, where there were
a lot of "Snowbirds" (Canadians who
spend winters in the south). I was
introduced to the phenomenon of
the aging "trophy wife" and their
fondness for elective surgery.

Nuclear Disaster mask, 1988
red cedar, paint, and cedar bark,
26 × 14 × 7 in.

Based on the *Bukwis (Wild Man of the
Woods)* mask (see page 124), this piece
was inspired by the Chernobyl disaster
of 1986 in the Soviet Ukraine. Since
that event, there has been another
major nuclear disaster, in Fukushima,
Japan, in 2011, so this mask is just as
relevant today.

studied Northwest Coast stories, searching for the meaning behind
the masks and crest animals that I create in my art.

Perhaps it is not too far-fetched to believe that creative energy can
be stored and then passed on. Nikola Tesla once said that to under-
stand the world one must understand vibration and energy. Scientists
still don't fully understand the nature of energy, but I can say with cer-
tainty that the old masterpieces I handled in those collections had a
visceral power, as though some force remained within them. Like a
caged lion that has lost some of its strength, those ceremonial objects,
hidden away in stark, lifeless storerooms, had lost some of their dyna-
mism, but enough remained that anyone who touched them would
know that they still held a spiritual vitality. I had the rare privilege of
holding in my hands some of the finest of the ancient masterpieces,
and they helped form my philosophy, interpretation, and approach to
Indigenous art.

AS MY RESEARCH on the ancient art and artifacts progressed, I rec-
ognized that while many of the carvings depicted characters from
the ancient stories, others portrayed people and events contemporary

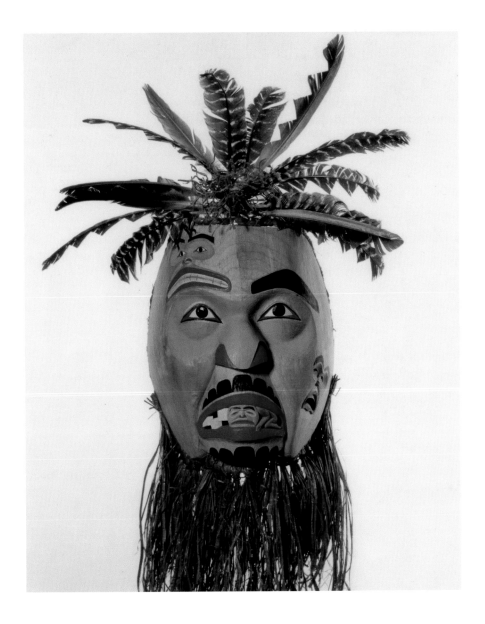

to the carver's time. In the collection of the Portland Art Museum, for example, I encountered a Tsimshian starvation mask, a striking carving that I understood to represent a time of hunger in the artist's lifetime. So, having established a historical precedent, I start carving masks to document, satirize, and critique contemporary events, issues, and people. With the assistance of a Canada Council grant, I created a series of twenty contemporary masks that became the *Spirit of the Earth* exhibition, which opened at the Vancouver Museum in 1993. The masks in the show included *Clear-Cut* mask, *Mother Earth* mask, and *Oil Spill* mask. Along with the carvings were text panels featuring

above

Overpopulation mask, 1992
alder wood, paint, cedar bark, and turkey feathers, 30 × 12 × 8 in.

A traditional approach to a contemporary topic, this mask strives to convey a feeling of overcrowding and being pressed upon from all sides.

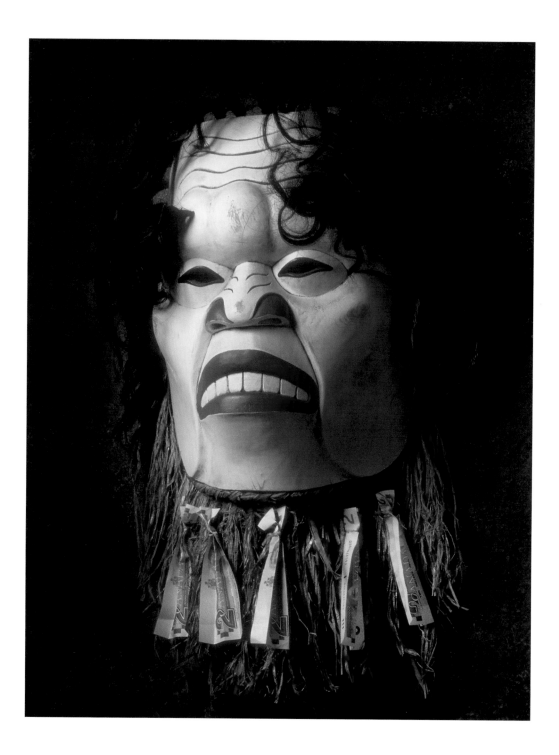

Mask of the Injustice System, 1991
red cedar, paint, horsetail, and Canadian
currency, 24 × 12 × 10 in.

This mask, in the tradition of a ridicule mask,
portrays the judge who ruled against the
Gitxsan and Wet'suwet'en people in their 1991
land claims case, stating that life was "nasty,
brutish, and short" for Indigenous people
before Europeans arrived.

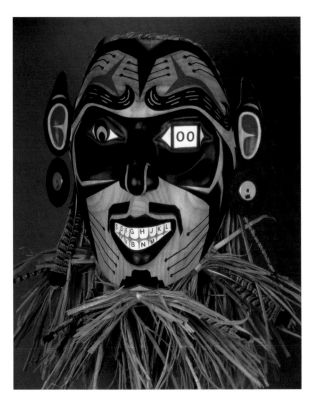

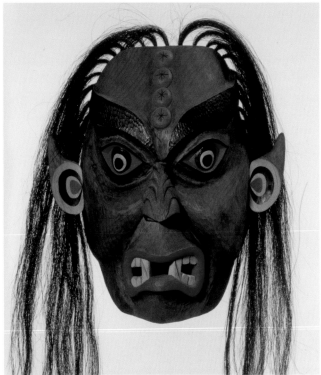

quotes that reflected traditional Indigenous philosophy about the environment – for example, from Chief Seattle, "All Things are connected. Whatever befalls the earth, befalls the children of the earth." The combination of contemporary masks and quotations reflected the knowledge of early Indigenous people and strived to blend ancient wisdom with new ideas. The work captured the public's imagination, and *Spirit of the Earth* travelled to several Canadian public art galleries, including the Penticton Art Gallery, the Yukon Arts Centre, and the Thunder Bay Art Gallery.

Another very fine old carving that has survived and had an influence on my work is a frontlet by Simeon Stilthda in the collection of the National Museum of the North American Indian. It depicts a chief's daughter who had died at a young age. It is a moving depiction of a parent's love for his late daughter – a memorial. It was this work in particular that inspired me to carve portrait masks of members of my family, including my mother, Karen; my father, Dave Senior; my three children, Edwin, Ellena, and Charles; Ellen Neel; and Mungo Martin. I worked from photographs, striving not to simply re-create the person's facial features in wood but to capture his or her essence. I

left

Digital Trickster mask, 1999
alder wood, cedar bark, paint, computer disks, and feathers, 20 × 15 × 7 in.

The trickster is an important character in traditional Indigenous stories across North America – Mink, Raven, and Coyote are all creatures that symbolize the trickster mythos. In the cyber age, a new character is required – the Digital Trickster.

right

Oil Spill mask, 1999
alder wood, paint, and horsehair, 14 × 12 × 6 in.

Inspired by an oil spill in Burrard Inlet in Vancouver in 1999, this mask depicts the anxiety and fear inspired by maritime oil disasters. This style of mask has its roots in traditional Kwakwa̱ka'wakw culture. The *Sea Monster (Yagis)* dance mask, for example, represents a character from the ancient stories so powerful that it could destroy entire villages.

adopted this approach from photography, where the goal is to portray not just how people look but their character – to capture their essence in a still image. I wanted to do in wood what I endeavoured to do in my photographs; the emphasis was not on making an anatomically exact likeness of the person but a representation of something deeper and poignant.

Perhaps the most intriguing mask that I created during this period was the portrait mask of my grandmother Ellen Neel. Through the mask, I wanted to portray my grandmother's beautiful art, traditional knowledge, and peaceful soul. I gave the mask an assured countenance and facial features that were more refined than what I'd seen in photographs of her. The mask was intended to represent her interior beauty, so I carved features that symbolized her depth and passion. In other words, the mask was never intended to be a visual likeness of my grandmother: it was a symbolic representation.

In 1992 my daughter was born, and we named her Ellena after her grandmother. (The *a* at the end was added because when Kwak'wala speakers pronounced my grandmother's name they tended to add an "a" sound at the end, resulting in "Ellen-a.") As Ellena grew into adulthood, she began to look more and more like the mask, until the resemblance was chilling. Today, she says that the mask "freaks her out" because it looks so much like her. But the Ellen Neel mask was carved in 1990, two years before my daughter was born.

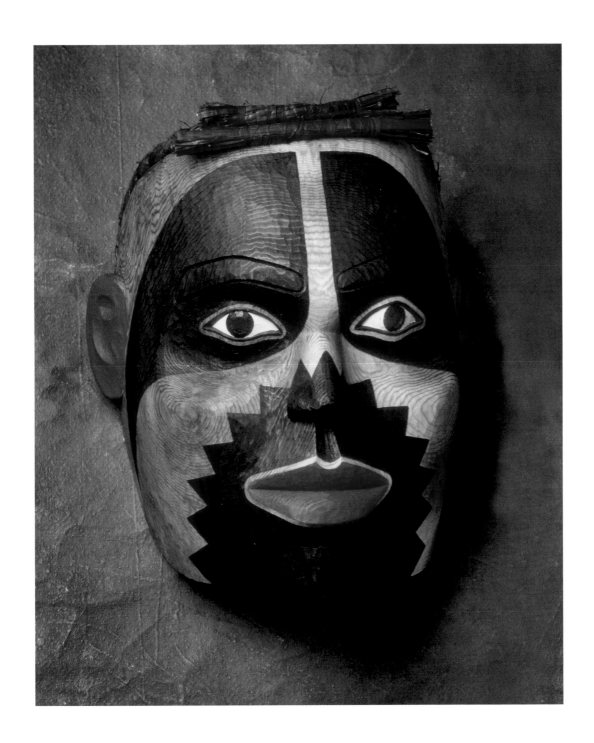

Karen Neel mask, 1992
alder wood, paint, horsehair,
and abalone shell, 14 × 10 × 6 in.

A portrait mask of my late
mother as a young woman.

**Dave Neel Senior Mourning
mask, 1992**
alder wood, paint, cedar bark,
and horsehair, 26 × 11 × 7 in.

Mourning masks are used traditionally
in Kwakwa̱ka'wakw culture. This one
was carved for my father to express my
feelings of loss and grief.

In 2017, the Legacy Gallery in Victoria had an exhibition of my grandmother's work, and the Ellen Neel portrait mask was included. My family danced at the opening event, and I photographed Ellena, who was then twenty-five, with the mask. The resemblance is truly uncanny. Most people would write this off as coincidence, but is it? Quantum physics has proven through the double-split experiment, for example, that human consciousness influences physical matter. I sometimes wonder if the Ellen Neel mask is an example of the power of the human consciousness. While I never intended it to be a realistic likeness or even a physical representation of my grandmother, it later proved to have an eerie likeness to my daughter.

THE CONTEMPORARY MASKS, it seemed, were ahead of their time, and my work was controversial. At the time, contemporary issues were not considered valid content for the art of Northwest Coast carvers. Indigenous artists were only supposed to create art that depicted animals or characters from the traditional stories. Issues such as land

My daughter, Ellena, in 2017 with the
portrait mask of her great-grandmother
Ellen Neel. The resemblance is striking,
even though the mask was carved two
years before Ellena's birth.

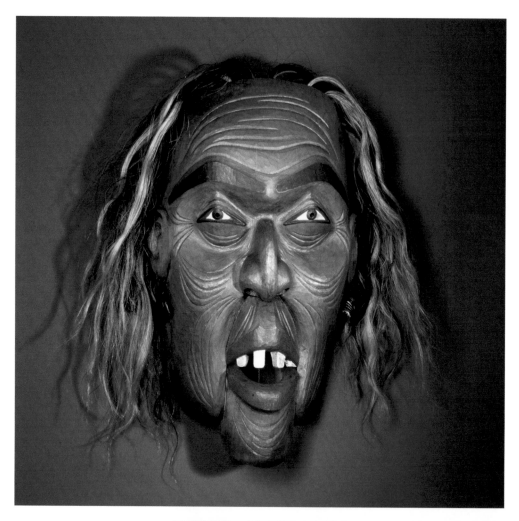

THE WAY HOME

claims, fishing rights, or Indian residential schools were not considered acceptable topics for a carver.

Many people supported my ideas, while a few were vocal in their opposition. One individual who repeatedly spoke out against my work was a Kwakwa̱ka'wakw. In addition to the usual gossip, this person wrote a lengthy diatribe in the comments book at one of my exhibitions and later wrote a letter to the editor that was published in the Victoria *Times Colonist*. I carved my response in wood: *Mask of Envy*. We all have a role in life: some people create, and some people criticize. This is simply a fact of life, and I didn't take it personally. My Aunt Emma Tamlin once advised, "Just keep in mind that when that individual is busy criticizing you, some other person is being left in peace."

Some of my contemporary masks went on to exhibit internationally, including in Phoenix, Zurich, and London, where I was presented to Queen Elizabeth and Prince Philip. In 1998, the Canadian government hosted a series of cultural events for the Royal Reopening of Canada House on Trafalgar Square in London, including an exhibition of Indigenous art. Several artists journeyed to England for the opening, including Dempsey Bob, Joe David, Beau Dick, and me. When the Queen and Prince Philip arrived, we formed a reception line. Beau Dick was to my left, and when the Queen and Prince came to us, Prince Philip commented, "Actually, we have a totem pole at Windsor Castle" (referring to the one carved by Mungo Martin in 1958 and given to Queen Elizabeth by the government of Canada). Beau, never one to be shy, pointed to me and replied, "Yeah, that totem pole was carved by his grandfather." As he shook my hand, Prince Philip added, "Well, then, you will have to visit Windsor Castle." We exchanged a few pleasantries with the Queen, and then the royal party moved down the reception line. Later, we were chatting among ourselves when the

facing top
Mask of Envy, 1992
alder wood, paint, horsehair, and deer toes, 18 × 12 × 8 in.

When I returned home after twenty-five years away, I was welcomed by almost all of my people, except one. In response to that person's animosity, one of my elders advised, "Just keep in mind that when that individual is busy criticizing you, some other person is being left in peace."

facing bottom
Dempsey Bob and Beau Dick sing while I dance the Holikila at the Royal Reopening of Canada House exhibition, London, England, in 1998.

Queen and Prince Philip made their way to the door, surrounded by their security team. Prince Philip caught my eye, gave a little wave, and said, "Don't forget to visit Windsor." I smiled and waved back, and then they were out the door. I haven't yet had the opportunity to visit Windsor Castle and see Mungo's totem pole, but it is definitely on my bucket list.

THE ONE-HORNED MOUNTAIN GOAT

A man once had a dream about obtaining supernatural power from a one-horned mountain goat. In the morning, he told his sons of his dream, and the boys took their four dogs to search for the supernatural mountain goat. After four days of searching, they found the goat, but they had to climb high up the mountain to shoot it with their bows. They didn't follow the spiritual practices their father had told them must be used when taking an animal's life. The youngest brother reminded them about the ritual, but they didn't listen to him.

After the mountain goat was butchered, the youngest brother saved some tallow, which he held in his cheek. Soon, a great snowstorm came and trapped the boys. Only the youngest boy survived the snow and freezing cold, as he was led by his dog to a safe place. When the boys didn't return, people from the village tied cedar planks to their feet so they could walk on the deep snow and went in search of the boys. When they finally located them, only the youngest was alive, although he was partially frozen.

They carried him home and performed a sacred wolf dance to heal him. They found the precious mountain goat tallow in his cheek, and when it was removed, it grew to fill the house, and the people had a great feast with the tallow, which was a rare delicacy. Revived by the sacred dance, the boy

heard the sound of paddles when he awoke. He found that he was beside a lake where he used to go fishing with his brothers. In the distance, he saw a canoe approaching. Realizing that it was a supernatural canoe, he dove under the water and held fast to its bow. The spirit creature asked the boy to release the canoe and in return it would give him supernatural powers.

The boy slept in the forest, and in the morning he found the house of the Cannibal at the North of the World. He told the Cannibal that he wanted to become a *Hamatsa*. He was given a red cedar bark neck ring and arm rings and a small piece of hemlock, which he wove into his hair. When he returned to his village, he came out of the woods dancing the cannibal dance and crying "hap, hap, hap." When he arrived at his father's big house, he removed the hemlock from his hair, and it transformed into a Humpspeck (Cannibal) totem pole. He taught the people the dance to go with it, snaking his body in and out of the mouth holes of the faces.

INTERLUDE: PAINTINGS

WHEN I FIRST became interested in canvas painting, I quickly realized that it would require learning new skills. I was already proficient in photography, carving, engraving, jewellery design, and painting traditional formline designs, but canvas painting, with its broader palette of colours, was another discipline entirely. As always, the work began with sketches, lots of sketches, to develop my ideas and a direction for my work. I knew a couple of painters and I asked them for advice, which was helpful, and I studied several books on colour theory. Initially, I kept these books close at hand in order to develop a personal palette of colours. I also started working with acrylic paint with which I was familiar from painting masks, but later on I switched to oil paint, which is more tactile and allows for colours to be built up in layers.

I had been researching the ancient stories for a number of years, so my first series of paintings depicted the characters and scenes from traditional tales. Influenced by ideas that I had seen in my father's paintings and elements of Northwest Coast Indigenous style, my work was initially playful and whimsical. Colourful characters were set against a background, which was reminiscent of a photographer's backdrop, with elements from the stories suspended or hanging from ropes, chains, and hooks. I did about twenty canvases before that series was complete.

Traditional formline designs are somewhat abstract and people often have difficulty seeing the animal being depicted. In my next series of paintings I took that abstraction in a new direction. These

paintings incorporated ideas borrowed from modernism to explore the "split," which is one of the fundamental elements of Northwest Coast Indigenous design. As the series progressed I continued to use the split as a core element in my compositions, but the work became more surreal, combining ovoids with abstract elements that played with space and composition. In this series of thirty-six pieces, the canvas proved to be an ideal place to explore how elements of traditional design relate to composition and use of space.

The final series of paintings was based on the masks that I had studied in public collections when I first set out to become an Indigenous artist. In these works, colourful masks depicting characters from the ancient stories were set against backgrounds that incorporated designs from petroglyphs, which I had long been interested in. In hindsight, I feel that my time would have been better spent carving masks rather than painting them, but it seems to be in my nature to try new things in art media. It is rewarding creatively, but it is a long and winding path, and I think of myself as having a long "creative bucket list." After finishing this series of thirty-six paintings, I decided to simplify my life and art practice, focusing on carving and hand engraving and I left painting behind.

The Young Chief, 2002
acrylic on canvas, 48 × 36 in.

facing

The Bear Mother, 2003
acrylic on canvas, 60 × 48 in.

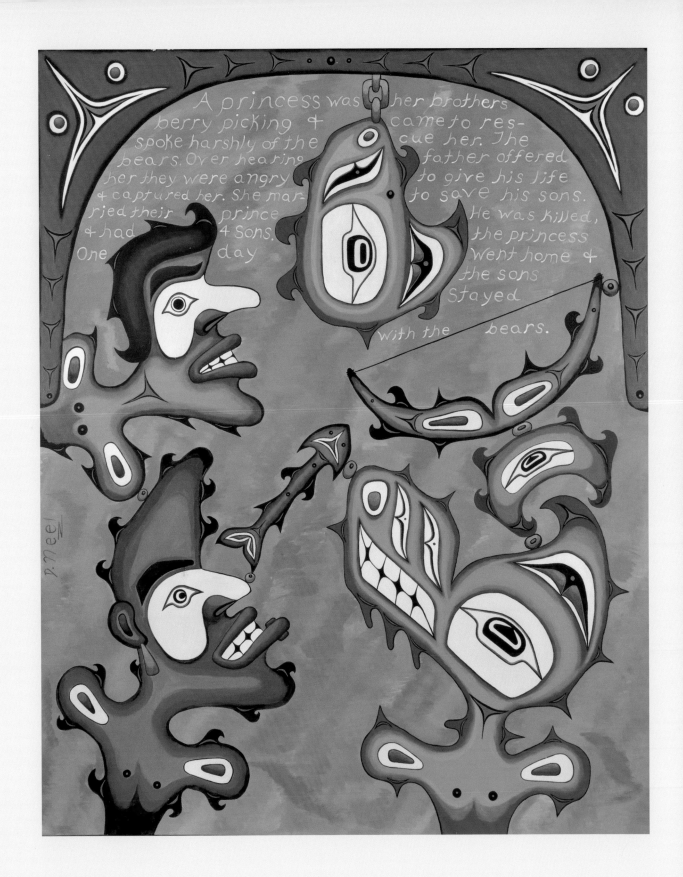

above

Wildman of the World, 2008
oil on canvas, 39 × 31 in.

facing

A Chief before a Mirror, 2007
oil on canvas, 51 × 39 in.

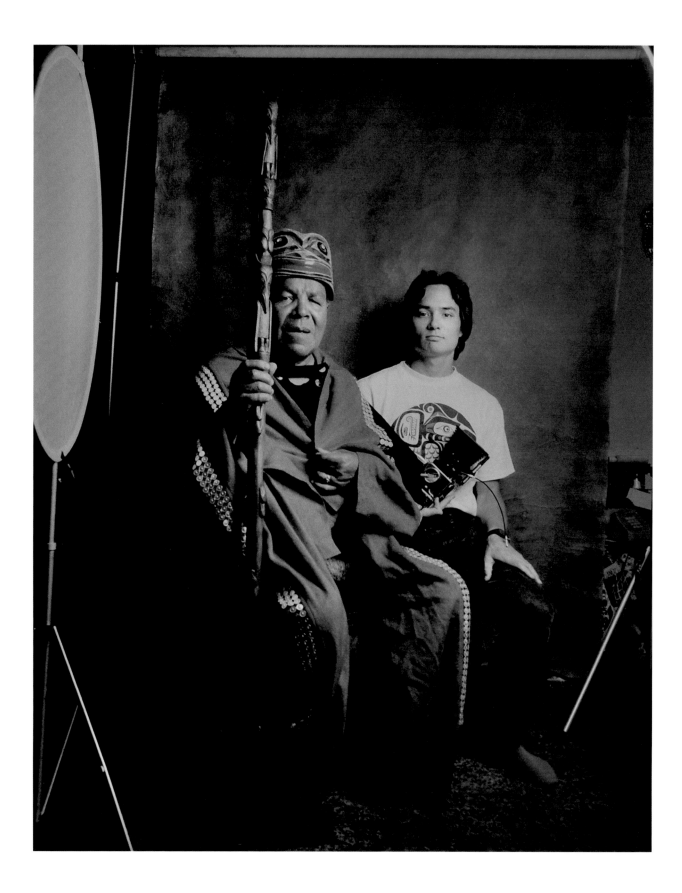

4/ **LESSONS**
CHIEFS AND ELDERS

THE BEAR PRINCESS

A group of women were out picking blackberries. One of them, a princess, was known to be a complainer. She whined about the thorns, and she complained about the small size of the berries. She wasn't paying attention to what she was doing and stepped in some bear dung, and in anger she loudly cursed the bears. Blackberries are a favourite of bears and, not far away, they were also picking berries. They heard her, and because of her disrespect, they abducted her and took her to their village. After they arrived, the bear chief's son fell in love with her and took her for his wife. She was happy living among the bears, and they had two children, who took after their father's side, appearing more bear than human.

That fall, the princess's brothers found the bear village. The princess's father, who was heartbroken over the loss of his daughter, told his sons to raid the village and recover their sister. The princess heard dogs yelping in the distance and knew at once that her brothers had found her. The bear prince and his family escaped into the woods, but the brothers picked up their trail with the help of their dogs. After a long pursuit, the bear family was cornered in a mountain cave. The bear prince knew that they were hopelessly trapped and offered to exchange his life for the safe passage of his sons. The brothers agreed, and they slayed the bear prince for abducting their sister. They took the princess back to their father's village, and the cubs returned to their home, the bear village.

facing
I prepare to take a photograph of Chief Charlie Swanson in his home in Greenville, BC, 1989.

facing top row
Catherine Adams (Gwa'sala-
'Nakwaxda'xw) holding a traditional
copper (left) and with her pet kitten
(right), 1988.

facing bottom row
Chief Edwin Newman (Heiltsuk/
Kwakiutl), 1988.

Shortly after returning to Vancouver, I began another photographic documentary project, applying the experience that I had gained in Texas. But this time, I would be working with my people. From 1987 to 1989, I photographed and interviewed chiefs and elders from a variety of First Nations communities in British Columbia, including Nisga'a, Haida, and Kwakw̱a̱ka'wakw. I visited small rural villages as well as urban reserves, and after finishing a photography session with a chief or an elder, I asked him or her who else should be included in the project. I photographed and interviewed a wide variety of people, looking for a group that would be representative of BC First Nations.

I don't really know what motivated me to photograph and interview elders within just a few months of my return, but in hindsight they possessed just the knowledge that I needed. I had been away from the culture for the developmental period of my life, a period when the mind is like a sponge, soaking up experiences and information. By visiting the cultural and political leaders of a wide range of communities, I was exposed to the knowledge and teachings I had missed. I would like to claim that I had been clever and developed a plan to gain knowledge from the best sources, but I think it was simply beginner's luck.

One elder I interviewed told me something I will never forget. I had heard rumours from other people that satanic ritual abuse had taken place in residential schools, but I was only vaguely aware of it at the time. I asked the elder if they had personally witnessed abuse while attending residential school, and the elder replied, "Yes, and because of what I saw I have never been able to heal and recover." I gave the statement little thought until the Truth and Reconciliation Commission's investigation into Canada's Indian residential schools, which confirmed that thousands of students were subjected to disease, physical

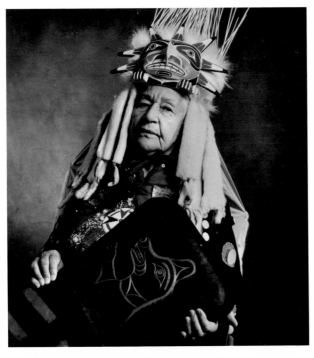

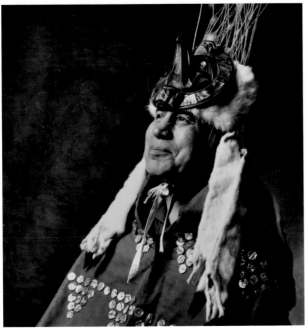

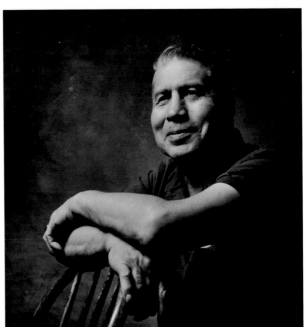

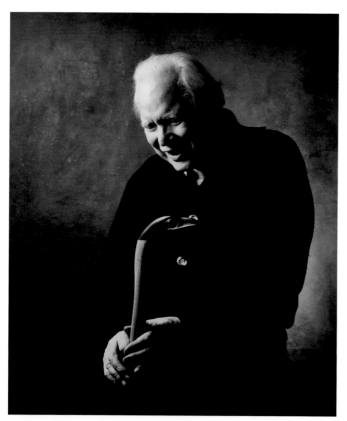

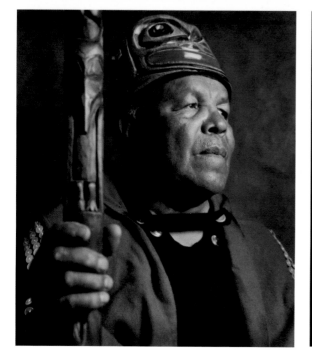

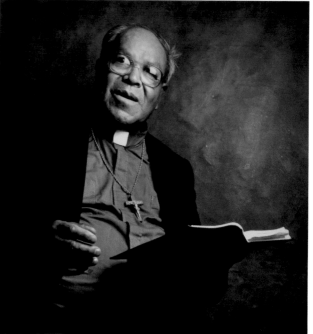

and sexual abuse, as well as medical and psychological experiments. Although I didn't know the importance of this disclosure at the time, the elder's words echo in my mind to this day.

For more than a year, I continued to interview chiefs and elders, and I took portraits in their homes, incorporating personal elements from their surroundings, using a portable lighting system and canvas backdrop. My professional experience in the United States served me well, and I was able to do magazine-quality photography in people's living rooms, smoke houses, or woodsheds. For some reason that I have never entirely understood, there is something about the photography process that emboldens people to speak more freely, to open up and share. It is difficult to comprehend how immediate and universal this is, but in my years as a professional photographer I have seen it time and time again. Something of a transformation also takes place in me when I do photography: I become more observant, more aware of the subtleties of people's words and gestures and even of my surroundings. The change happens as soon as I take up a camera. I automatically take in the brightness and quality of the light and the features of the background, and I start thinking about how I want to portray the subject. People respond; they seem to sense something has changed and open up to the camera, and we are able to quickly establish a dialogue that wouldn't happen if the camera and lighting were not present.

The people I photographed were a diverse group that included Chief Edwin Newman (Heiltsuk), Chief Ruby Dunstan (Lytton), Chief Rod Robinson (Nisga'a), Chief Adam Shewish (Nuu-cha-nulth), Chief Leonard George (Tsleil-Waututh), and elders such as Agnes Alfred, the matriarch of the 'Namgis, who was over one hundred years old when I photographed her. These people opened their homes and shared their

words and knowledge with me. They had the experiences that I had missed, and as children they had sat on the laps of their elders and heard the teachings and stories that had been passed down for generations. In their youth, they'd learned traditional skills from their parents, learned to sing and dance, and had all the experiences that make Indigenous people unique – all the experiences that I had missed. But I had come home with skills that allowed me to make up for lost time, and to absorb some of their knowledge, as a photographer and writer.

Over a two-year period, I did about fifty interviews in the homes of elders, and it is difficult to put into words what I learned, as they taught me so much. Sometimes, it is a gesture or a pause or a facial expression that accompanies a person's statement that is rich in meaning. The elders told me what it was like to grow up in another time, when people were independent and helped one another, when food came from the land and the sea, when bountiful home gardens and fruit trees were common, and when the fall was a time for drying, smoking, and canning. The elders spoke of a time when traditional community values that had been handed down from time immemorial were still strong, a time when the ways of the "white man" were still foreign. I listened to stories of change, persecution, and forbearance, and sometimes it was difficult to listen. An elder told me about when she and her two sisters were sick at residential school; she told me of her sisters dying without a doctor ever attending them and of her own survival. The elders told me of a time when the whole of the BC coast was alive with fish in the summer and logging in the fall and winter; it was a time of prosperity.

I listened to a chief talk about the time, years ago, when his father gave away ten thousand dollars at a potlatch – the first time it was ever done – and about how he was the first to give away gold earrings and gold bracelets at his potlatch when he assumed his chieftainship, a

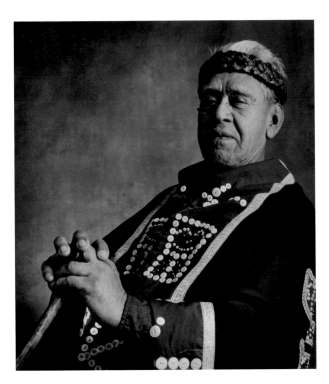

time when gold was thirty-nine dollars an ounce. The elders explained to me what it means to be a hereditary chief and the responsibilities that come with it; they explained the role of an elected chief councillor and how they work together for the community. I heard about what it means to be *mudzith*, a chief's wife, which in Kwak'wala means "always holding up her skirt" so she won't trip as she hosts their many guests. I learned the importance of respect and of upholding the family name and about how many things had changed in their lifetimes. They talked to me about traditional healing and about how knowledge was passed down within a family and within a community. One elder told me about learning to be a midwife and a traditional healer, starting when she was nine years old. They told me about what it is like to be part of a community, one where people share a common history and work together. The elders told me of another world that existed in the recent past, a world that had changed before their eyes. They told me enough to fill a book, several books, and laid a foundation of understanding that helped to make up for the years that I had missed. I took some of their teachings and put them in a book to share with others; some things can't be expressed in writing, and those things I kept in

facing
Chief Alvin Alfred, hereditary chief
of the 'Namgis, Alert Bay, BC, 1990.

my head and in my heart, and over the years I used them in paintings, carvings, prints, and jewellery. The teachings that I missed during my years away can never be replaced, but the words of the elders helped a great deal.

INTERESTINGLY, MY WORK first gained attention in Canada because I was in the right place at the right time. I was invited to speak as part of a panel of artists at the Vancouver Museum in 1988. The panel included senior artists such as Carl Beam and Robert Houle; I was so naive that I didn't realize they were two of the leading First Nations artists in the country and that I was completely out of my depth. I was the token young artist, but I had verve, and I spoke passionately about my work and projected slides that included the chiefs and elders photographs, which were in progress at the time. An undergraduate student from the University of British Columbia saw the images and told her professor, Marjorie Halpin, a curator at the Museum of Anthropology, about them. Marjorie called me the next week to set up a studio visit. At that time, I had a photography studio and darkroom in East Vancouver, where I did commercial and editorial photography and made my own black-and-white prints.

When Marjorie came to see my photographs of the chiefs and elders, she said they were unlike any photographs of Indigenous people she'd ever seen. Later, she wrote: "Neel's accomplishment is not merely to confront us with the existence of stereotyping by creating its absence, he also affords us glimpses of what social intimacy is about." I was offered an exhibition at the Museum of Anthropology, which was my first in a public institution. *Our Chiefs and Elders: Words and Photographs of Native Leaders*, opened in 1991 and was warmly received by the public and curatorial community. The photographs became my

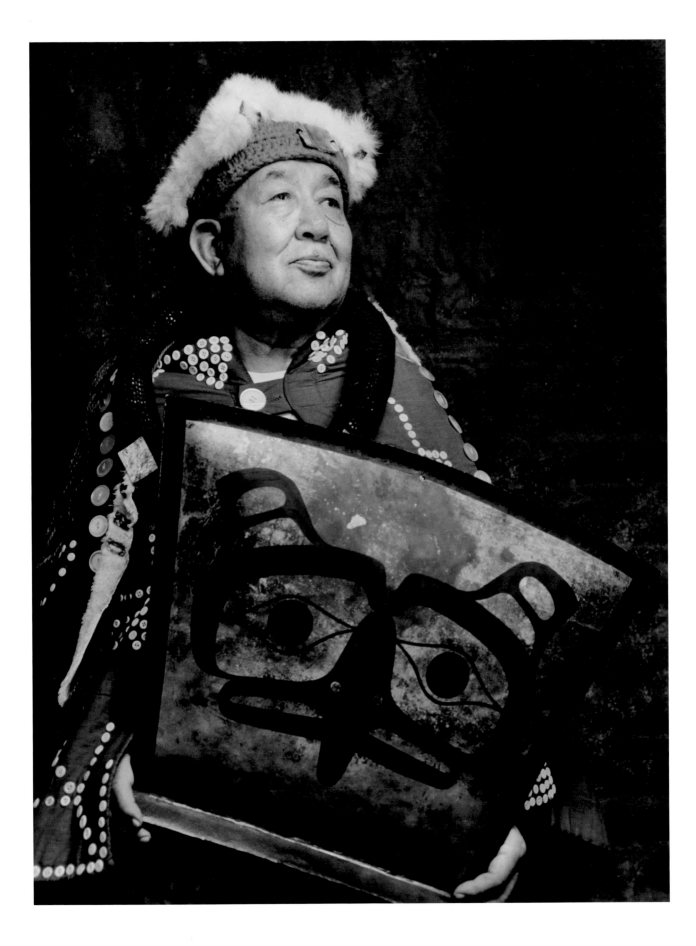

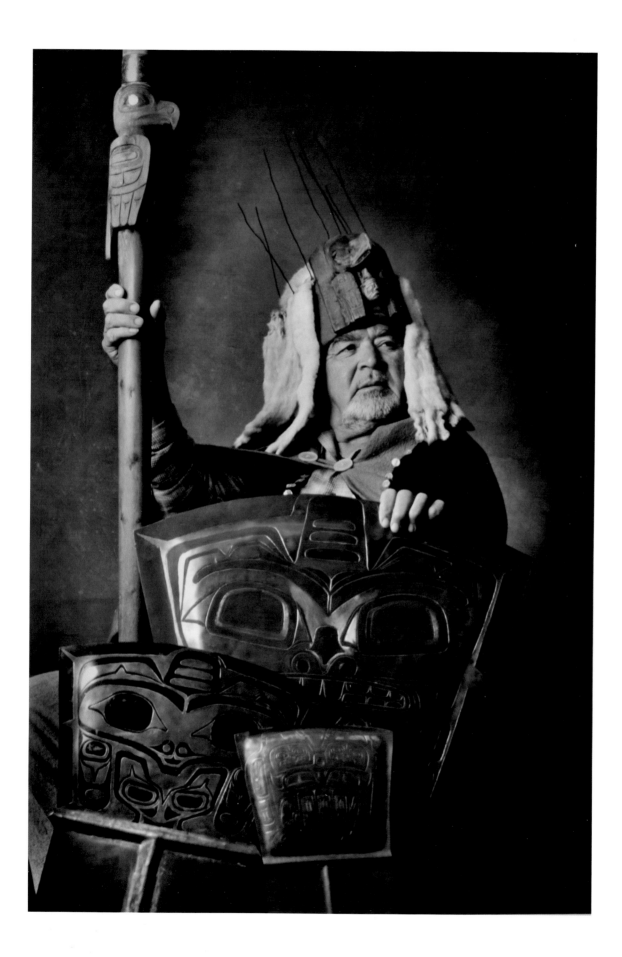

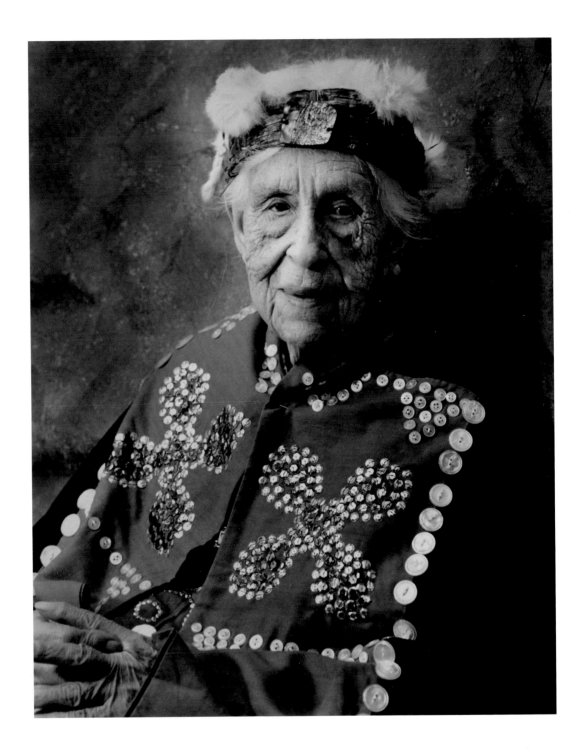

Chief Dempsey Colinson (Haida)
posing with his traditional coppers
and talking stick, 1990. He was
knowledgeable about Haida history
and culture and was a hereditary chief
in the true sense of the term.

Agnes Alfred ('Na̱mgis) was 101 years
old when she was photographed at
Alert Bay, BC, in 1990.

first book, with the same title, copublished in 1992 by UBC Press and the University of Washington Press.

Also in 1991, the National Archives of Canada added a portfolio of my photographs to its permanent collection and mounted a solo exhibition of my work in Ottawa. The *Our Chiefs and Elders* exhibition then travelled to more than a dozen institutions in Canada and the United States, including the Canadian Museum of Contemporary Photography in Ottawa, the National Museum of the American Indian in New York, the Burke Museum of Natural History and Culture in Seattle, and the Art Gallery of Greater Victoria.

IN THE SUMMER OF 1991, the BC Elders Gathering was hosted in North Vancouver by the Squamish Nation. The Elders Gathering is an annual event that brings together Indigenous elders from across British Columbia for a celebration of knowledge, culture, and ideas. While non-Indigenous people in their golden years are called "senior citizens," a term of dubious distinction, Indigenous elders are seen as the repositories of cultural knowledge and history and are high-ranking members of society. I approached the Squamish Nation Council and proposed an on-site preview of the *Our Chiefs and Elders* exhibition for the gathering. My uncle, Chief Edwin Newman, and I met with Squamish Nation representatives Chief Joe Mathias and Debra Jacobs, and they supported the idea. So, in cooperation with the Museum of Anthropology, we installed fifty framed portraits in a community building adjacent to the Squamish big house.

According to tradition, my family and I hosted a feast on the evening of the preview. I consulted members of my extended family – including Emma Tamlin and my Uncle Edwin and his wife, Vera – who were knowledgeable about our traditions, and with their support I

THE WAY HOME

planned what would be my first feast. I collected gift items, traditional foods, and cash to give to the dancers, singers, and witnesses. On the day of the feast, Uncle Edwin donated a five-gallon bucket of eulachon eggs on seaweed, which is a precious traditional delicacy. Aunt Emma had consulted with her family, and it was agreed that it would be appropriate for me to use their family copper. In Kwakwa̱ka'wakw culture, a copper is the foundation of a traditional event such as a feast. On the afternoon of the preview, the Kwakwa̱ka'wakw elders met to plan the feast. It was humbling to hear a number of senior chiefs and other respected community leaders – including Chief Willie Hunt, Chief Henry George, Chief Edwin Newman, Chief Henry Seaweed, and Chief Alvin Alfred and his wife, Ethel Alfred – speak in support of me, explaining that I came from the community and a traditional family. Their support meant a lot to me, and I worked with them on events a number of times in subsequent years.

At the time, the historic standoff between the Canadian military and the Mohawk Warriors was under way in Oka, Quebec, and Canada's Indigenous community was galvanized in support of the Mohawk people. This was a landmark event in Canada at the time and was front-page news for months. The town of Oka had attempted

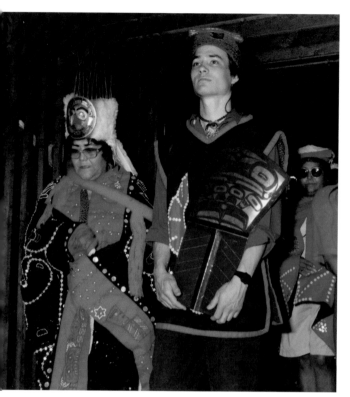 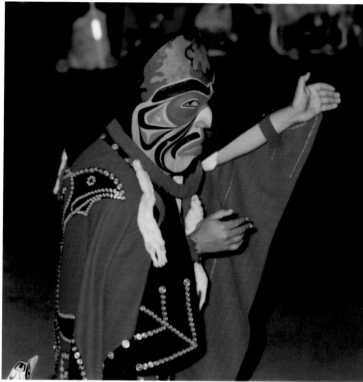

to expand a nine-hole golf course to eighteen, on land that was a traditional Mohawk burial ground, and the armed standoff lasted for seventy-eight days. I was working on the contemporary mask series at the time; I had carved a *Mohawk Warrior* mask, and I suggested that it be danced at the feast. The Kwakwa̱ka'wakw elders gave their unanimous approval to use the mask for a Blanket Dance in support of the Mohawk Nation. This dance is practised by Indigenous people across North America: a blanket is put on the floor of the big house or carried around the event area to collect donations for the cause announced by the host, which may be for a future traditional event, for a family who has lost a loved one, or for an Indigenous political cause, such as a court case or protest. That day, Richard George ('Nakwaxda'xw and A'wxa'mis) danced with the *Mohawk Warrior* mask to the beat of a Kwakwa̱ka'wakw drum, and we donated the money that was raised to the Mohawk Nation Defence Fund. This was done with the support of high-ranking Kwakwa̱ka'wakw chiefs and elders, in a traditional big house, with the elders from scores of BC First Nations communities present. It would be difficult to argue that masks portraying

contemporary topics are not a valid part of traditional culture, given what was witnessed that day.

That was the day that I came home to my people. There was a moment when I felt that I had arrived and been accepted – when the Kwakw<u>a</u>ka'wakw people entered the Squamish big house, with me holding a copper at the front of the group, my wife and baby son, Edwin, beside me, and the chiefs and elders and the others all in line, over a hundred of us. When the procession approached the front of the big house, where our *hamilas* (the dance screen that separates the spiritual world from the secular world) had been hung, the audience rose to its feet, as one, to witness our arrival. As I stood holding the copper in front of the hamilas, our singers sang a welcome song. With Chief Edwin and Vera Newman and my aunts – Emma, Pam, Theo, and Theresa – there to support me, I knew that I had finally, truly, come home. It was an inspiring moment. The elders were witnessing a young man who had created a photographic tribute to First Nations leadership in *Our Chiefs and Elders*. But for me it symbolized acceptance by my family, nation, and extended community. After being away for most of my life, it might have been impossible for me to return and immerse myself in the culture and community again – so few people manage to do this. But great-great-grandfather's Tsegame mask in Fort Worth, Texas, my apprenticeship with Beau Dick and Wayne Alfred, and the knowledge of the elders – collectively, these things had shown me the way home.

A YEAR LATER, in 1992, when *Our Chiefs and Elders* was published, my family and I hosted a feast and book launch at the Museum of Anthropology. With the support of UBC Press, I gave away hundreds of copies of the book, along with gifts and my book advance in cash. Gift giving

facing left
Emma Tamlin and I enter the Squamish big house at the head of a procession of Kwakw<u>a</u>ka'wakw chiefs and elders.

facing right
Richard George ('Nakwaxda'xw and A'wxa'mis) dances wearing the *Mohawk Warrior* mask in the Squamish big house. My mask was used in a Blanket Dance during the feast at the Elders Gathering, and we collected money for the Mohawk Nation to support its standoff with the Canadian military at Oka, Quebec.

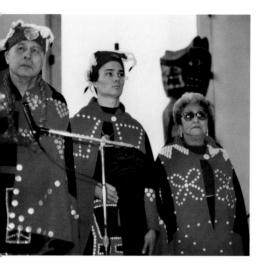

is an important part of Kwakwaka'wakw culture, and I was fortunate to again have the guidance of family elders, including Chief Edwin and Vera Newman, Emma Tamlin, Chief Alvin and Ethel Alfred, Chief Henry and Edith George. These people had grown up in the culture, were knowledgeable, and had the respect of the community. They understood how difficult it was to come home, and they helped me in many ways, providing a foundation for my efforts and offering advice. The book was read and the exhibition seen by many people, so the words of the chiefs and elders have been shared widely, and judging from the comments that I have heard, others have also found value in their knowledge.

Time passes, seemingly without notice, and my time with those people was many years ago. A follow-up to that body of work, *Our Chiefs and Elders: Tradition in the Digital Age*, is in progress. Indigenous tradition has its roots in the pre-contact period, before mechanization, yet it has survived despite great opposition. But today, Western society is in the midst of a digital revolution. Once again, I will go to the elders to ask what the role of traditional culture will be and how it might survive in this brave new world.

WILDMAN OF THE WOODS (BUKWIS)

Every year in the fall, a group of people went fishing for sockeye salmon together. There was a man who wanted to become a strong warrior, so every morning he walked far from the camp to bathe in a freezing mountain stream and purify himself. After bathing one day, he saw a chipmunk scurry by with its tail on fire, and he knew that he had seen something supernatural, an omen of something to come. He continued to walk down the mountain, towards the fishing camp, and suddenly he found himself

THE WAY HOME

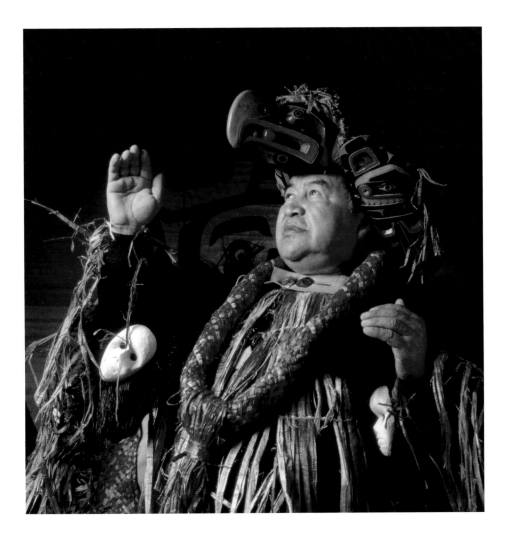

back at the mountain stream with no memory of how he'd got there. He
started walking down the mountain again, with the same result: he was
back at the stream with no memory of arriving there. He tried returning to
the camp again and again, with the same result each time.

Then he had an idea. He gathered the inner bark from a cedar tree,
braided it into a rope, and started walking down the mountain again. His
plan was to tie himself to a tree near the camp so he would be found by
his people. Halfway down the mountain, he tied himself to a stout alder
tree, and again he awoke at the top of the mountain. When he didn't return,
the people searched everywhere, but they couldn't find him and eventually
they gave up.

The next year, when the tribe returned to the fishing camp, two women
were in a canoe when they saw something moving on the beach. They
thought it might be a bear cub, so they paddled closer to have a look, and

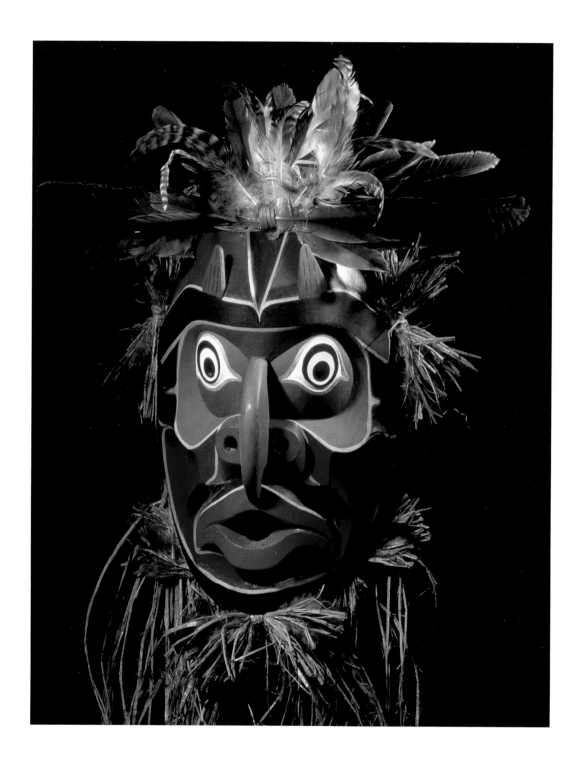

THE WAY HOME

to their amazement they discovered it was the man who had been lost the year before. They hastily returned to the fishing camp and told the people that they had found their lost friend.

The next day, they all went to the forest – only to discover that their friend had become a Wildman. They tried to surround him, but he jumped over their heads and escaped into the forest. The next day, they returned and tried again, with two men waiting out of sight in the bushes to grab him if he tried to escape. All the people of the fishing camp surrounded the Wildman and slowly moved towards him, and again he jumped over them and bolted towards the forest. The two men burst from the bushes and held him until the others could reach them. It took a dozen men to hold him down and bind his wrists and ankles. Then they took him to their big house, tied stout cedar planks on the sides, and put heavy rocks on the roof so he couldn't escape. They kept him in the house for four days, trying to tame him. They gave him their best food – salmon, halibut, and eulachons – but he only wanted to eat ants, worms, and grubs. The Wildman couldn't talk because his tongue had shrunk so much that he could only grunt.

The people consulted a shaman, who told them to give him dried, rotten wood from the forest mixed with salmon, and after four days of eating this the Wildman slowly began to talk and return to normal. He was tamed and became a member of the village once again. Afterwards, he was stronger and could jump higher and run faster than any of the other men. He became a great warrior, and all the other villages left his village and his people in peace.

facing
Bukwis (Wild Man of the Woods) mask, 2003
alder wood, paint, cedar bark, and goose feathers, 23 × 14 × 10 in.

The Bukwis is one of the most popular Kwakwa̱ka'wakw characters and often danced at traditional events. It represents a man who becomes wild and lives in the forest, eating a diet of bugs and grubs.

INTERLUDE: **PRINTS**

INITIALLY MY INTEREST in printmaking was inspired by the work of my grandmother Ellen Neel. It was Roy Henry Vickers, a Tsimshian artist and printmaker, who told me, in 1989, that it was my grandmother who had first combined silkscreen printing and Northwest Coast design. There were no limited-edition prints when she was working in the 1950s, so she applied the technique to a range of mediums, such as note paper and silk scarves. I have one of her scarves in a frame on my wall today.

In 1988, while I was apprenticing as a carver, I did my first limited edition silkscreen print, *Sisiutl and Full Moon*. It depicts characters from ancient Kwakwaka'wakw stories, unlike my later work, which explores my interest in contemporary history and Indigenous issues. Having lived through a dynamic period in First Nations history, I felt compelled to deal with Indigenous concerns and historically important events in my work.

In 1991 the standoff between Mohawk Warriors and the Canadian military galvanized the Canadian Indigenous community, and for months there were support protests for the Mohawk people all across Canada. I developed the idea of doing a poster/print not only to raise awareness but also as a fundraiser for the Mohawk Nation Defence Fund. I produced a mockup using press photographs and paint (in the days before computer design) and then contacted the Union of BC Indian Chiefs, where I got an appointment with the director, Chief Saul Terry, to ask him to support the project. He liked the idea, and *Life on the 18th Hole* was born. It combined an image of a Mohawk Warrior from the front page of the *Globe and Mail* (Canada's national

newspaper) with photographic and hand-rendered elements, resulting in a hand-pulled, silkscreen print.

We printed posters that were shipped to the Mohawk Nation for fundraising, and a limited edition print was released, many of which are in public collections today. The press picked up on the image and *Life on the 18th Hole* was reproduced in many newspaper stories about the Mohawk standoff. It was reprinted in about twenty publications, and, as I am writing, it has been reproduced on the cover of the current issue of the *Journal of Canadian Art History*. It has also been included in numerous exhibitions in public institutions, such as the Institute of American Indian Art and the National Gallery of Canada. In 1993, I attended an Indigenous fundraising event in Vancouver and discovered that there was a bootleg version of the poster for sale.

There have been a number of Indigenous events of historical importance that have occurred in recent years, such as the repeal of the anti-potlatch law. I believe that one of an artist's key roles is to create work about social issues and contemporary history, and I have done several prints over the years about contemporary issues. Another serigraph, *A Strong Law Bids Us Dance*, represents the Kwakwa̱ka'wakw tenet that our masks, songs, and potlatches form a time-honoured institution that supersedes Canada's laws. This is evidenced by the fact that Kwakwa̱ka'wakw potlatches continued to be held in secret during the years of cultural repression and the banning of the potlatch from 1885 to 1951.

Today, I focus on traditional formline design, which is informed by my research on old bentwood boxes and traditional stories. I still like

Life on the 18th Hole, 1991
serigraph on paper, 28 × 22 in.

This poster and limited-edition print was commissioned by the Union of BC Indian Chiefs to raise funds during the Mohawk Crisis in Oka, Quebec. It has been printed in numerous publications and exhibited in a dozen public institutions.

to introduce new ideas, and I cannot stay completely within the lines: my most recent print, *A Box of Daylight,* depicts Raven releasing not the sun, according to legend, but the Seed of Life, from Sacred Geometry. The Seed of Life, which has a profound spiritual significance, is used to symbolize the deeper nature of this popular "myth," which tells the story, metaphorically, of the creation of the universe.

Having studied the ancient stories for many years, I see them through different eyes today. They have age-old knowledge encoded within them and offer a glimpse into an ancient world. There is a wealth of information in traditional Indigenous tales, which are part of a long-standing oral tradition. I am interested in making them available to a contemporary audience in a written format, so I include the legends as written statements that accompany my prints. While the delivery of the age-old stories may change, the essence of the tradition remains the same.

68/75 Life on the 18th hole.

above

A Strong Law Bids Us Dance, 1992
etching, photo etching, and aquatint on
paper, 14 × 20 in.

This print represents the
Kwak<u>wa</u>ka'wakw tenet that our masks,
songs, and potlatches together form a
time-honoured cultural institution that
supersedes Canada's laws.

facing

Broken Promises, 2017
serigraph on paper, 23.5 × 20 in.

This print is a tribute to the Standing Rock Sioux
in their struggle against the Dakota Access
Pipeline being built on their traditional territory.
It was the first time that Native American
people used social media to bring international
awareness and support to a political issue.
The central photograph is of Chief Red Cloud
(Oglala Lakota), who led a successful campaign,
now known as Red Cloud's War, against the US
military in 1866–68.

Heroes #1 – Sitting Bull, 1992
etching, photo etching, and aquatint on paper, 17 × 14 in.

This print was commissioned for the cover of a book on AIM, the American Indian Movement. Sitting Bull, a Hunkpapa Lakota leader, took part in the Battle of the Little Bighorn in 1876 and fought against the United States Cavalry until he and his warriors surrendered in 1881.

facing

Just Say No, 1990
serigraph on paper, 26 × 22 in.

This print pays tribute to Chief Elijah Harper, an Oji-Cree politician and first Indigenous member of the Legislative Assembly of Manitoba, who stood against the Meech Lake Accord in 1990, a series of constitutional amendments that had been initiated without input from Canada's First Nations. Harper's stand was a historic event because it was the first time that Indigenous people had a representative in government to stand up for their interests.

Just Say No 1/35 D. Neel '91

above

One Earth, Four Races, 1993
serigraph on paper, 26 × 26 in.

The central image depicts Mother
Earth with the four races of humankind
around her – red, yellow, black, and
white. It represents the common bond
among all people. Four is an important
number in the natural world (four
seasons, four directions, etc.) and in
Indigenous culture; in the ancient
stories and ceremonies, things often
take place in fours.

facing

A Box of Daylight, 2018
serigraph on paper, 26 × 15 in.

The popular story of Raven releasing
light to the world is depicted here in
the form of a bentwood box. In ancient
times, the world was dim, and there
was no sun in the sky. An old man had
stored the sun in a cedar box. Raven
tricked him into letting him play with
it and then flew away, releasing it into
the sky. In this piece, I have replaced
the sun with the seed of life, which,
like the sun, is a universal symbol of
creation.

4/50

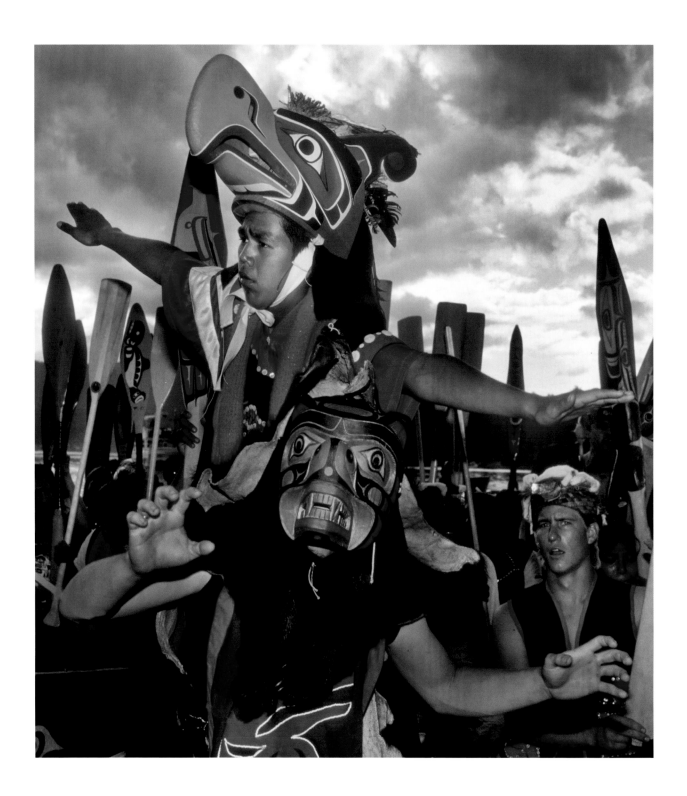

5/ RESURGENCE
THE GREAT CANOES

THUNDERBIRD AND GRIZZLY BEAR

In ancient times, when all the creatures were still learning how to live on the earth, a man decided that he would build himself a house that would be large enough to hold all his extended family. He cut down a number of large cedar trees and shaped them into house posts, crossbeams, and slabs to cover the exterior. When he had the material ready, the man found that he had neither the strength nor the knowledge to erect them, so he sat down on one of the logs to give the problem some thought. While he sat there, he noticed that a huge Thunderbird was watching him. The man said, "It's too bad that you aren't a man, so that you could help me." To his surprise, the Thunderbird said, "I am a man," and he took off his feather coat to show him that inside he was human. Then he put on his feathers again, took a log in his powerful talons, flapped his wings, and lifted the log into place.

After the house was complete, the Thunderbird was invited to stay and be part of the community. So he took off his feathers, transformed into a man, and married the chief's daughter. After he had lived there for a long time, he told them he was homesick and wanted to return to his home in the sky but that he would always protect and help the people. As a symbol of this promise, he said that from now on, whenever one of his human descendants died, thunder and lightning would fill the sky. To this day,

facing

Kwakwaka'wakw dancers wearing a Thunderbird headdress and Bear mask while dancing in the bow of the 'Namgis canoe, the *Galuda*, as the pullers rhythmically beat their paddles on its gunnels. The Thunderbird is Ronnie McKinny, and the Bear is Simon Wallace.

facing

The *Keleila* (Butterfly) canoe on the water near Victoria, BC. This thirty-two-foot red cedar canoe was carved with the assistance of students from the Coquitlam School District as a teaching project, and it was used on journeys to a number of canoe gatherings in BC.

thunder rolls, the heavens weep, and the lightning flashes whenever one of the descendants of the Thunderbird passes on.

After the Thunderbird had returned to the heavens, the people still needed a protector, so it was decided that ties would be formed with the Grizzly Bear. According to the custom of the day, a marriage was arranged between a Grizzly Bear prince and one of the princesses of the village. Since that time, the lineage of that first village has used the Thunderbird and Grizzly Bear on its totem pole.

My generation has seen traditional Northwest Coast culture and art grow strong and flourish – unlike my great-great-grandfather, in whose time the culture was illegal and was practised only in remote villages away from the authorities. Yet nothing can compare to the return of the traditional dugout canoes, which hadn't been used by Indigenous people for many decades. I was privileged to witness, from the beginning, the resurgence of these ocean-going vessels. I was among the crews of Indigenous people who paddled to the first canoe gathering at the village of Waglisla (Bella Bella) in 1993, at the invitation of the Heiltsuk chiefs. Six years later, I carved a canoe and paddled it through the canals of Venice, Italy. But I am getting ahead of the story.

Indigenous dugout canoes all but disappeared from the Northwest Coast when motorized boats became popular at the turn of the twentieth century. Previously, canoes were the predominant mode of travel used by Indigenous people all along the coast of Alaska, British Columbia, and Washington State, centuries before a Canada–US border existed. They were carved from red cedar trees that were often more than five hundred years old and as much as three to five feet in diameter.

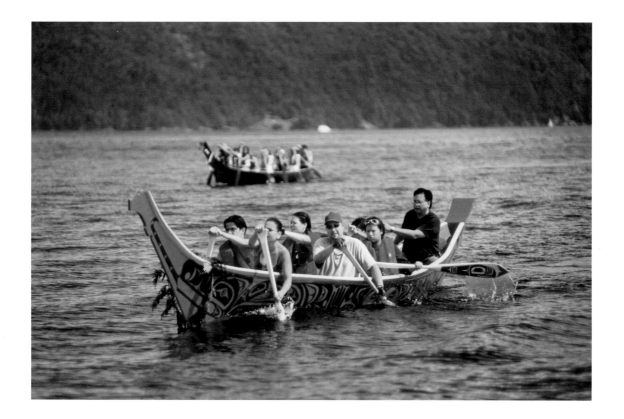

The cedars were huge, so the old masters felled the trees and carved them deep in the forest, where they found the best old-growth cedars. They carved them into a rough canoe shape and then left them to dry for a season. The next year, they returned to the forest and continued their carving. When most of the moisture had left a canoe and it was thoroughly hollowed out, it was much lighter, so it could be pulled down to the sea and towed to the beach in front of the village, where the final carving was done. To fall a tree and carve it into a finely finished dugout canoe with only hand tools was not an easy task, and I have the greatest respect for the superb work that they did with no power tools or electric lights.

By 1990 there were probably only about a dozen dugout canoes on the Pacific coast. Then came an event that changed history: the Paddle to Bella Bella. The Heiltsuk Nation put out a challenge for people to build canoes and paddle to Bella Bella, which lies on the Pacific coast, a thousand kilometres north of Vancouver. Dozens of tribal nations accepted the challenge, and dozens of canoes were carved for the first time in generations.

Searching for an old-growth red
cedar log in a sorting yard near
Campbell River, BC. After a lot of
hunting, a five-hundred-year-old
tree with a tight grain and few knots
was selected.

facing right
Ellena visits with me as I take a break
from hollowing out a cedar canoe,
Campbell River, BC, 1994.

At that time, I was living in Campbell River, on the east coast of
Vancouver Island, and operating a family-run art gallery. The local
First Nation, the Wei Wai Kum, had a seven-hundred-year-old log that
they were carving into a forty-foot canoe, and I offered my services as
a photographer to document the journey. After the canoe was com-
pleted and the paddlers began to train for the trip, I carved myself a
paddle from yellow cedar and joined in as a puller. We paddled in the
fast-flowing waters of Discovery Passage, learning to navigate and
using the tides as our ancestors had done for centuries.

Then, in August 1993, the canoes began to arrive in Campbell River.
The tribes that had paddled the farthest, such as the Puyallup, James-
town S'Klallam, and Makah, had started from their villages in Wash-
ington State. They were joined by the canoes of the First Nations of
southern British Columbia, such as the Squamish and Tsawwassen, as
they journeyed north along the coast. The First Nations villages along
the route hosted the paddlers and support crews, and communities of
a few hundred residents served meals and provided accommodations
for several hundred people, and we feasted like the ancestors. Tradi-
tional foods were donated by the locals, and the big houses witnessed
singing and dancing by the Kwakwa̱ka'wakw, Haida, Nu-chah-nulth,
and other nations. We paddled during the day and danced to tradition-
al songs long into the night. By the time we arrived in Bella Bella, there
were more than fifty canoes and over a thousand people from many
tribal nations. It was a historic event that inspired a generation. In the
years that followed, the canoe gatherings continued, and each sum-
mer since 1993 a different tribal nation has hosted a gathering.

MY BOOK *The Great Canoes* was published in 1994. It documented
the return of the ocean-going canoe tradition, combining interviews

with people involved in the resurgence of the canoe culture and photo-graphs of the preparations and journey to Bella Bella. By the time the book was released, I had visited several canoe-carving sites and had developed a good understanding of the process. I'd been carving for seven years by that time, and everything I had seen inspired me to carve my own dugout canoe.

I contacted a local logging company, and they agreed to donate a log. It was intimidating to walk among hundreds of logs at the sort-ing lot near Campbell River, searching for a close-grained, knot-free log. If I chose a bad log, it might have interior rot, which is common among old-growth trees. But I was lucky, and I selected a five-hundred-year-old tree that had a wonderfully tight grain. It had some damage where the loader had crushed the wood while picking it up, but I knew I would be able to repair it. I'd met with representatives from the City of Campbell River and had been given permission to carve my canoe at the public park on the waterfront, where four house posts, which had been carved by my Uncle Bob Neel, stood facing the water. It was the

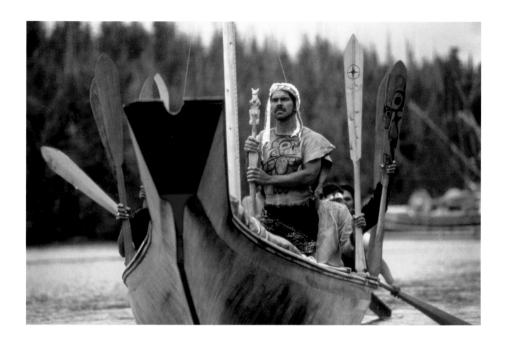

perfect carving site, on the bank of Discovery Passage, with my Uncle Bob's house posts supporting a roof over my canoe.

In preparation for the carving, I spent a lot of time researching traditional dugout canoe–building techniques, and I naturally went to ask the renowned Haida artist, Bill Reid, for advice. I'd been visiting Bill at his Granville Island studio and his Kitsilano home since 1987, asking questions, observing, and learning what I could. He was one of the first Indigenous artists I had visited upon returning to Vancouver. During our first conversation, he told me that he remembered both Mungo Martin and Grandma Ellen. I was working as a professional photographer in those days, and I photographed him for my book on chiefs and elders and for a number of clients, including *Native Peoples Magazine* and the Canadian Museum of Civilization. Over the years, I had received assignments from a number of magazines to photograph other prominent artists, such as Susan Point, Jim Hart, Lyle Wilson, Robert Davidson, and Doug Cramner, but I visited Bill on numerous occasions, and he was always generous with his time.

In 1988, I'd been at False Creek, in Vancouver, for the launching of two fibreglass replicas (*Black Eagle* and *Red Raven*) of Bill's cedar canoe, the *Lootas* (Wave Eater). The *Lootas* was a fifty-foot masterpiece that Bill had carved for Expo 86. Four fibreglass replicas of the *Lootas* had been made, and he'd loaned one of them to a group of First Nations

paddlers for the trip to Bella Bella in 1993. I'd paddled beside their canoe many times on that journey, and I knew it to be a well-crafted and seaworthy vessel. The Museum of Anthropology at the University of British Columbia also had an earlier dugout canoe of Bill's on display, and I studied that vessel as well. It was twenty-five feet long and very well made.

When I talked to Bill, he told me a number of things that helped a great deal. For example, a dugout canoe has almost no straight lines; even lines that appear straight often have a flowing curve that gives the vessel its visual grace. He explained something that Mungo Martin had told him: how to use a flexible stick to make straight lines with a slight, flowing curve. This technique would prove to be immensely helpful when I was laying out the lines on my canoe. But the most remarkable thing Bill taught me was not about carving or canoes. When I went to visit him at Granville Island and I explained that I wanted to carve a canoe and wanted his advice, he said, "You're the first Native artist to ask my advice, although I was one of the first carvers in modern times to make a traditional cedar dugout. Artists nowadays seem to think that they can carve a canoe just because they have Native blood." I was stunned. At the time, he was undoubtedly the most accomplished living Northwest Coast artist, and no one had ever sought him out to seek his advice? It took me some time to process this; it seems that many people, not just First Nations carvers, are reluctant to seek advice from knowledgeable experts. Perhaps they are too shy, while others may fear that they will be rejected, and still others may be too proud. I have always been inclined to seek knowledge from the most capable sources, and I've never hesitated to approach talented people for advice. Bill's comment made me realize that my approach was unique, and until then I had thought everyone asked for

facing:
Bill Reid's canoe, the *Looplex*, a fibreglass replica of his cedar masterpiece, the *Lootas* (Wave Eater), en route to Bella Bella, BC, for the historic canoe gathering in 1993. For several decades before that event, there were only a handful of Northwest Coast canoes in use on the Pacific Coast.

advice as needed. He helped me understand why I'd been able to learn from leading photographers and artists: it was simply because I was open to asking for help and advice.

Before starting my dugout canoe, I did extensive research. I studied everything that I could find about canoe carving, researching the historic canoes in public collections, such as the masterpiece at the American Museum of Natural History in New York. But one of the finest canoes I've ever seen is much closer to home: on display at the Royal British Columbia Museum, it is a cedar masterpiece, a perfect example of a Northwest Coast canoe, and I spent a lot of time studying its superb lines and details. I also observed and asked questions of other canoe carvers, including Calvin Hunt, Bill Henderson, and Mervyn Child, who was especially generous with his time and knowledge.

Mervyn travelled from Fort Rupert to help me rough out my canoe in Campbell River. Without his help, I don't know that it would have been the able vessel that it is. Based on my research, I had made detailed sketches to scale and then set about carving a twenty-six-foot canoe from a five-hundred-year-old tree. With less than a decade of carving experience, I should have found the task daunting, but I had seen enough canoes being carved that I could visualize the process in my head. I have always felt that anything that can be visualized can be made, given enough time and effort.

Around this time, my wife and I went our separate ways, and I found myself a single parent with three children: a four-year-old and two-year-old twins. My children's mother, of pure Nuu-chah-nulth heritage on both sides of her family, had attended Indian residential school in Mission, BC, for many years. Her Nuu-chah-nulth family lived on the west coast of Vancouver Island and, like many First Nations children, she grew up far away from the care and love of her

family. Children who grew up in that institutional, authoritarian, and abusive environment were denied the teachings and tenderness of their families, and healing is sometimes a long process. When we separated, my children were raised in a single-parent home, much as I had been. Looking back, I'm amazed by how much more I got done in a day than I do now: in addition to raising three children, carving a canoe, and hand engraving jewellery, I was also doing photography. Today, it makes me tired just remembering how much I used to work.

With the canoe half-finished, I relocated my family from Campbell River to North Vancouver, where I would be closer to galleries and my customers. We rented a home on the Squamish Nation reserve, and my children grew up in an urban Indigenous community. The Squamish are warm-hearted people, and they welcomed the children as members of the community. The children attended Easter egg hunts, Christmas parties, and community events with the local children. And I got back to work on the canoe.

This was a time of cultural resurgence, and there was a lot of interest in canoe carving. People from the reserve dropped by the carving site I had erected beside my house, and my neighbour Maurice Nahanee and his uncle Willy Nahanee were constantly helping out. We used the long summer evenings to work on what was starting to look more like a canoe and less like a cedar log.

The really amazing part of building a dugout canoe is the steaming process. Bill Reid once told me that the Northwest Coast canoe is the only steam-bent vessel in the world. The process is ancient, and it has been handed down over countless generations. Red cedar can be steam bent to increase the width of a vessel by as much as 50 percent. The canoe must first be hollowed out to about two finger widths (one and a half inches) on the bottom and one finger width

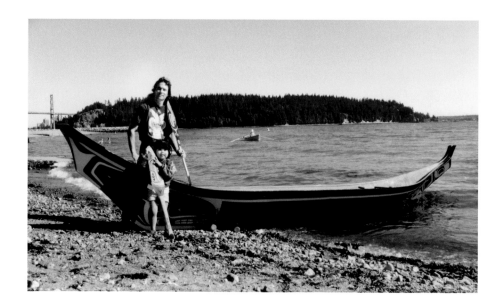

above
Ellena and I with the *Walas-Kwis-Gila* (Travels Great Distances) canoe at Ambleside Beach, North Vancouver, 1997.

facing
The crew of the *Walas-Kwis-Gila* training on Burrard Inlet, BC, for the voyage Paddle to Puyallup, Washington State, 1998.

(three-quarters of an inch) on the sides; if the wood is too thick, it will be stiff and won't steam properly. My canoe was about thirty inches wide before steaming and forty-five inches wide afterward.

The steaming process begins with water being poured into the canoe to a depth of about six inches. River rocks are heated in a fire until they are red-hot and are then put in the canoe, one at a time, until the water boils. The canoe is covered with layers of wood and canvas to hold the heat in. More rocks are added periodically to keep the water near boiling, and over the course of a few hours the side walls of the canoe become flexible, assuming the texture of thick rubber. It is amazing to witness cedar transform from a stiff wooden board to something with the flexibility of a hard rubber eraser. Precut sticks are then used to gently push the sides of the canoe apart, and once it has been spread to the desired width all the way along the vessel, hardwood crosspieces are attached to the gunnels with wooden dowels, to make the side walls stay in place after the cedar has cooled. No metal screws or nails were used in the canoe. If all this is done correctly, you can look down the canoe from one end to the other, and it will have the flowing lines essential to a well-crafted Northwest Coast canoe.

After the steaming was complete, I painted a Thunderbird on the bow and a Killerwhale on the stern, which are the main crests of my family. I opted to use a tough, marine enamel paint because I wanted the canoe to be durable and reasoned that a modern marine paint would help. It was a good choice: years later, the sides of the canoe were still undamaged. With my canoe, the *Walas-Kwis-Gila* (Travels Great Distances), finished, we were ready to use it for what it was intended: paddling the waterways of the Pacific coast.

THE JOURNEY TO the annual canoe gathering begins with one or two dugout canoes, and as the trip progresses they are joined by the canoes of other tribal nations until, finally, there may be twenty, thirty, or more canoes journeying together. Hosting the canoes as they stop on their journey is a huge commitment for a First Nations village. It takes the entire village population working together to feed and provide housing for the hundreds of people that make up the canoe teams and their ground crews. The generosity of the villages speaks volumes about the respect Indigenous people have for their cultural traditions.

I took the *Walas-Kwis-Gila* on numerous short trips and two major journeys: first to a gathering in Washington State hosted by the Puyallup Tribal Nation and later to the 1997 North American Indigenous Games in Victoria, BC. It takes a lot to prepare for a canoe journey, and we start months in advance and continue to work during the journey, when we carve and repair regalia and masks if we're not paddling. Some of the younger pullers may not have dance regalia, so vests, tunics, or button blankets have to be sewn for them. A button blanket or dance shawl will often have over a thousand mother-of-pearl buttons sewn on it by hand, taking many hours to create. Each puller is

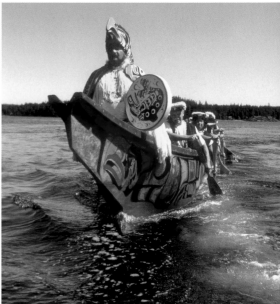

required to have his or her own paddle, so paddles are carved from tight-grained, knot-free yellow cedar. Northwest Coast paddles have a distinctive shape, with elegantly curved edges and a pointed tip. (Bill Reid once told me that in the old days, warriors had paddles that were carved especially for fighting on the water. Those "war paddles" would have been carved from extremely hard yew wood and had fierce pointed tips for fighting while controlling the canoe.) In addition to the million details to think of when preparing for a trip, such as carving tools, camping gear, and food for the crew, the route has to be planned in advance and the host villages notified, so they will know how many people to prepare for. Of course, there are always more people and canoes than expected, and the organizers sometimes have to scramble at the last minute to accommodate everyone.

Protocols for the gatherings, the importance of which cannot be overstated, are overseen by chiefs, elders, and the host community, in consultation with the canoe skippers. Of all the efforts made to prepare for a canoe gathering, the protocols are the most complex. The community hosting the canoe gathering selects a site in their traditional territory to be the designated landing point and chooses a day

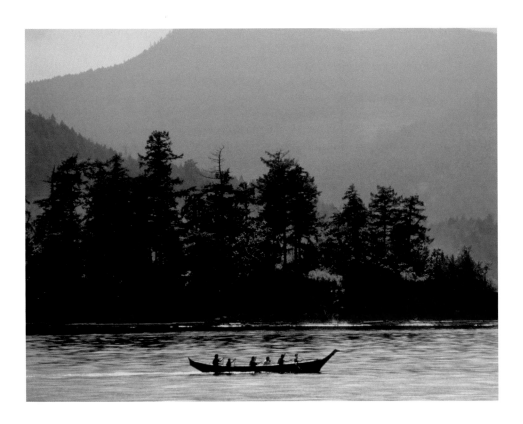

for the canoes to arrive. The skippers then coordinate the daily schedule of "pulling" so the crews all arrive together on the predetermined day. The day on which the canoes arrive can be chaotic; since they are coming from many different villages and different directions, it is impossible to schedule their arrival to the minute. The host community and the hundreds of witnesses on the beach may have a long wait, regardless of the weather. Eventually, the canoes congregate offshore, usually rafting up in groups by tribal nation (Kwakw<u>a</u>ka'wakw, Squamish, Haida, and so on), and wait until they are invited to come ashore.

The canoes that have travelled the farthest are the first to be invited to the beach. Each group of canoes comes to rest about twenty metres offshore, where they announce who they represent and request permission to come ashore. The hereditary chiefs and the elected chief wait on the beach to hear their speeches, and then they welcome the canoes to their territory and invite them to land. When the canoes arrive on the beach, their crews become the guests of the host nation and are given food and lodging or a place to camp. In keeping with tradition, the speeches may go on for hours, until all the canoes have come ashore.

The dance performance on the Grand Canal. The symbol on my blanket is a Thunderbird, the main crest of my family.

Then the feasting begins. The evening meal, which may be served in the big house or a nearby community hall, usually consists of traditional foods such as eulachon eggs, dried eulachons, fresh salmon, deer or moose meat, seal meat, dried seaweed and, of course, the intertribal favourite – fry bread. There will also be North American food, such as roast beef, chili, salads, buns, coffee, tea, and desserts. It is always a sumptuous and generous buffet, and after a day on the water the crews have big appetites.

After the meal, cultural presentations start in the big house. The big house will usually have a fire in the centre, regardless of the time of year. The keeper of the fire was traditionally an honoured hereditary position. Someone from the host community, sometimes the elected chief or a hereditary chief, will serve as the speaker. The host is often the first to sing, and the floor is then opened to the other nations to share a song. A Kwakwaka'wakw song, "Oh-kan-ee-ya," which is owned by Chief Robert Joseph, has become the Canoe Nation Anthem and is usually sung by all the tribal nations. The song was often led by the late Chief Frank Nelson, who was a hereditary chief, cultural leader, and supporter of the revival of the ocean-going canoe culture. He was a powerful singer, and I recall hearing his sonorous voice many times in the big house as he sang the opening lines of a song known to the entire canoe community.

It is amazing to see the cultural traditions of a dozen tribal groups in the course of an evening, all under one roof. This is a contemporary phenomenon: in historical times, there were no such large intertribal gatherings, and it would have been unheard of to see Tsimshian, Tlingit, and Kwakwaka'wakw people performing in a big house on a single evening. At the end of each performance, the visiting tribal nation typically gives a gift to the host nation, often traditional items,

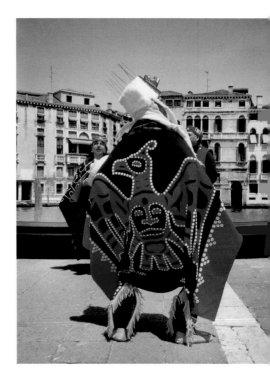

such as button blankets or paddles, which may be quite valuable. In Bella Bella, for example, the Kwakwaka'wakw chiefs gave the Heiltsuk people a small canoe with a Thunderbird design painted by Mark Henderson. Depending on the number of nations present, the dancing may go on into the early hours. Feasting with Indigenous people requires stamina: Nuu-chah-nulth and Kwakwaka'wakw potlatches often end at six in the morning. As the last group finishes dancing, the pullers, with full stomachs and tired after a day on the water and a night in the big house, find their way back to their lodgings to rest up for another day of paddling and feasting.

ANYONE WHO HAS visited Venice knows that the City of Masks is a magical place. Riding on the Grand Canal and exploring the smaller canals in a gondola with a skilled gondolier should be on everyone's bucket list. But exploring the canals of Venice in my own cedar dugout canoe was surreal, something from a dream.

In 1999, I took the *Walas-Kwis-Gila* to Venice to participate in the forty-eighth Venice Biennale. Established in 1895, the Biennale is one of the world's most prestigious art events, and many countries have artists exhibiting. The Vancouver curator Elspeth Sage, recognizing a parallel between the masks of Venice and the masks of Northwest Coast culture, organized a site-specific exhibition in a palazzo on the Grand Canal. Venice and the Northwest Coast also have long histories as marine-going cultures, with water travel essential to their way of life. The idea of doing a project in Venice appealed to me because the "discovery" of North America had changed global trade routes and helped make Venice a world power, so, as I saw it, the destinies of that fabled city and the Indigenous people of Canada were intertwined.

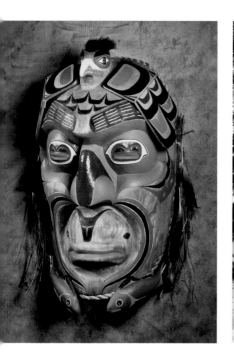

Elspeth proved to be an organizational wizard. The year before the Biennale, she travelled to Venice to rent a venue for my exhibition – an installation of my contemporary masks. We were very fortunate, and she found us a five-hundred-year-old palazzo right on the Grand Canal. She also rented a four-bedroom apartment, a short ferry ride away, for the canoe crew, who would be assisting with the paddling and dance performance. International shipping turned out to be a headache because we only had the option of a twenty- or a forty-foot container. When we crated the twenty-six-foot canoe and paddles in the forty-foot container, there was enough room left over for four more canoes, so we ended up paying a lot of money to ship a great deal of empty space.

The weeks leading up to the event were hectic, and I spent long hours carving and preparing our regalia. I got a lot of help from friends and supporters, who were happy to see me included in a major international art event. I carved a steering paddle with an Orca design, as it seemed appropriate to paddle in Venice with a creature of the sea. The week before we left for Venice, Rick Erickson, a member of the crew, hosted an event to preview the masks at his Vancouver home. A dedicated art collector, Rick loaned me the *Keeper of the Animals* mask from his collection for use in the exhibition. The forty-eight-inch

mask, which has multiple faces and flapping wings controlled with strings from within, represents humanity's role as a steward of the animal domain.

We arrived in Venice in July 1999, a week ahead of the exhibition, and as it turned out, we were fortunate to have arrived with enough time to sort out the problems that awaited us. After transporting the masks, dance regalia, and other gear to the apartment, we were exhausted. The next morning, we were supposed to pick up the *Walas-Kwis-Gila* from the Port of Venice and see it safely to the palazzo, which was located in the centre of the city, just ten minutes from the Rialto Bridge. Elspeth contacted the port and learned that the canoe had arrived as expected. But she was told there were "complications." The complications were in fact hurdles that took days to resolve, and at one point it looked like the canoe might not be released by Italian Customs in time for the Biennale. As we counted down the days to the big event, we checked every day with the port authority to see if the snags preventing the release of the canoe had been cleared. Two days before the event was to begin, we were informed that there were some "extra costs" for importing the canoe; once we'd paid the required fee, we would be welcome to pick up the contents of our shipping container. The Italian customs people knew, of course, that, like so many others, we were there for the Venice Biennale and needed our shipment by opening day. We were at their mercy.

On a scorching summer day, after many days of waiting, our shipping container was released. The customs seals were cut off, the doors were swung open, and the wooden crate that protected the canoe was pried apart. As we eased the canoe out of its wooden sarcophagus, the crew and I were elated to see that it was undamaged. A crane picked it up and lowered it into the waters of Venice.

facing left
Keeper of the Animals mask, 1991 alder wood, paint, cedar bark, abalone shell, and fur, 48 × 24 × 12 in.

This mask depicts creatures that are endangered species.

facing right
The *Walas-Kwis-Gila* moored outside a palazzo on the Grand Canal. The design on the bow (right) is a Thunderbird; on the stern (left), a Killerwhale, which are my two main family crests. This image shows the distinctive lines of a Northwest coast dug-out canoe.

I will always remember that first journey. It was the first time a Kwakwa̱ka'wakw canoe, or any Northwest Coast Indigenous canoe, had visited Venice: it was history in the making. Nothing could have prepared us for the reception we received from the local people, who'd never seen anything like the *Walas-Kwis-Gila*. Carved from a single tree, with a high prow and stern, and painted with dramatic Thunderbird and Killerwhale designs in black and red, the canoe was a remarkable sight as we passed under the Rialto Bridge and through the ageless waterways of the City of Masks. Like the Indigenous peoples of the Pacific coast, Venetians are people of the sea, so they have an inherent interest in boats. Everywhere we went, they waved to us as though we were celebrities, and we were welcomed by shouts of "Bellisimo!" as we passed. Wherever we stopped, Venetians came by to visit and study our unusual vessel.

As I steered the dugout canoe through circuitous waterways that were old before Canada was a country, I imagined what my father would have said had he been there with us, paddle in hand. That day, I felt the eyes of the ancestors upon us. In the prow sat Maurice Nahanee, who'd helped with the final stages of carving the canoe, including the steaming and then the painting. As lead paddler, he set the pace for the other pullers, with precise, tireless strokes. Just in front of me sat Rick, who had travelled to Campbell River to help on the first day of carving, when the *Walas-Kwis-Gila* was still a log. In front of him was Cheryl Rivers, from the Squamish Nation, a singer who had considerable paddling experience. And there we were, paddling in the waters of Italy, for the Venice Biennale.

When we arrived at the palazzo, we had to work out a way to secure the canoe for the night. Unfamiliar with the local waters, customs, and bylaws, this proved to be a challenge. After some deliberation,

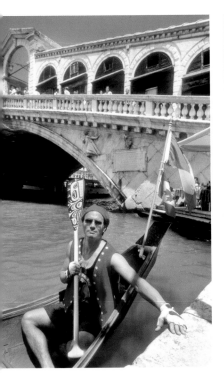
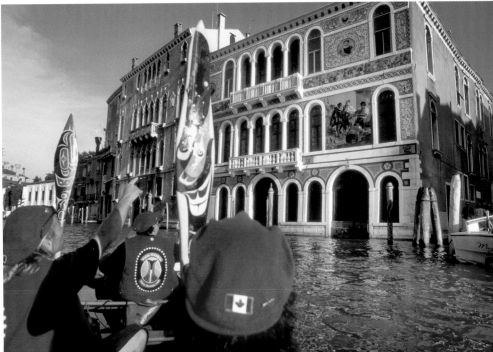

we secured the canoe, bow and stern, to wooden posts, which were mounted in the water outside the palazzo. When we returned the next morning, we found the canoe secure, but we had been unaware of the amount of tidal rise and fall in the canal, and the rubbing of the posts as the tide went down had caused considerable wear on the canoe. Leaving it on the canal at night was not an option, so we had no choice but to take it out of the water and store it inside the palazzo. The canoe weighed about four hundred pounds, and there was no dock nearby, so taking it out of the water each night and putting it into the water each morning was a daunting task.

The installation of the masks in the palazzo, however, was accomplished without any complications. The centuries-old brick walls were well suited to displaying art, and there was a good-sized reception room and a large room for the exhibition itself. Once again, it seemed that the ancestors were looking out for me because in the building across from our palazzo was the venue for an exhibition, titled *Ceremonial*, by some of the leading contemporary Native American artists

from the United States. It included works by Richard Glazer Danay, Harry Fonseca, Bob Haozous, Frank LaPena, Jaune Quick-to-See Smith, Kay Walking Stick, and Richard Ray Whitman, as well as poetry by Simon Ortiz. So, simply by good fortune, the only Indigenous artists exhibiting in Venice had venues within twenty metres of each other, allowing visitors to take in both exhibitions in the same location.

The day of our Grand Canal performance was sunny and very warm, so we were good and hot in regalia made for the climate of British Columbia. But with the canal as our backdrop, we sang Kwakwa̱ka'wakw and Squamish songs and danced for an international audience. The masks were not intended to hang lifelessly on a wall, and it was a pleasure to make them come to life to the beat of the drum on the Grand Canal. If it were possible to go back in time, just to one moment in the past, I would like to relive that July day when Kwakwa̱ka'wakw masks danced in the City of Masks.

CHIEF OF THE ANCIENTS

In the time of the ancestors, Chief of the Ancients lived among the people. One day, he called together the birds and told them there was going to be a winter dance and that they would all be painted lively colours. At that time, the birds were not yet colourful, for they were still human.

So Chief of the Ancients started painting the different birds in beautiful colours – Harlequin Duck, then Loon, then Golden Eye Duck, and then many other birds. After a time, he got tired, so he called on his younger brothers to help him paint. Then he left them to finish, as he wanted to burn the bottom of his canoe so he could make war on the World Beyond the Ocean. He asked his younger brothers to paint the birds in attractive colours, like the birds that he'd already painted.

Chief of the Ancients had spent two days painting the birds in brilliant colours, but his brothers were lazy and did their work quickly. While Chief of the Ancients was working on his canoe, his brothers started by painting Eagle, making him black with just a bit of white at each end; then Black Duck, whom they painted only black; then Loon, making him black with just a little white around his neck. When Chief of the Ancients returned, he was angry with his brothers for their shoddy work, so he called Deer to come and help him.

Deer called Spoon Bringing Woman to help, and together they painted Oyster Catcher, Albatross, Swan, and Pin-Tailed Duck. But they also lacked patience and only dabbed a little white paint on them. When the birds were all painted, Chief of the Ancients called his Aunt Fern to lead everyone in the dance. To the beat of a log drum, all the bird people danced from one end of the beach to the other. Suddenly, someone saw smoke at the other end of the beach, so everyone rushed to see what was burning. Chief of the Ancients found that his cedar canoe was on fire. Some people thought that he'd caused it by being careless when burning the bottom, and others said one of the birds must be angry for being painted sloppily.

Chief of the Ancients was upset, because without his canoe he couldn't make war on the World Beyond the Ocean. He told everyone that they would all disperse and never gather again. They organized themselves into pairs and scattered to the four corners of the world, and that is why some birds have striking colours while others are simply black or grey.

INTERLUDE: JEWELLERY

I SOMETIMES WONDER what people see when they look at a Northwest Coast ring, pendant, or bracelet. Do they see an ornament, an adornment, or simply a stylized picture of an animal? What I see is a symbol. It might be a symbol of love, accomplishment, or bereavement. People use jewellery to symbolize the most important events, feelings, and memories in their lives. I have always been aware of the role my art plays in the lives of those who collect it, and I think the role of jewellery is as important as that of sculpture or painting. A number of people have commissioned me to make jewellery to celebrate a loved one's battle with a critical illness, and I believe this is the highest calling for a jeweller. I have always felt honoured to have my work embody something so important in a person's life.

Hand-engraved designs of thunderbirds, wolves, hummingbirds, and other animals also symbolize characters from the ancient stories. I have studied the traditional stories for many years. They offer a glimpse into an ancient world, and I continue to marvel at their endless complexity and rich allegory. Jewellery designs are lush with meaning; for example, while a wolf design may represent an animal that lives in the forest, it also represents the traditional stories that tell of Wolf's role as the Keeper of the Tides and as a healer. The designs are connected to a rich history of dances, songs, and stories that have teachings and information encoded in them. Having an understanding of that history has enhanced my admiration for and appreciation of the designs that I hand engrave on precious metal. When I have a raw piece of silver, gold, or platinum in front of me, I see a blank canvas, or a clean piece of sketch paper waiting for inspiration.

Over time, I have learned to appreciate the sophistication and complexity of Northwest Coast flat design, which is characterized by fluid compositions applied to gold, silver, and platinum with great precision. Hand engraving has allowed me to explore and understand design principles and composition with a degree of freedom and intimacy difficult to achieve in another medium, such as painting or carving. Hand engraving is well suited to Northwest Coast design because of the high degree of exactitude that can be achieved with a graver, which is essentially a miniature carving knife that is extremely hard and sharp, so it glides effortlessly through precious metals.

The essence of Northwest Coast jewellery is precision, and I endeavoured to explore this concept to the fullest extent in two silver-and-gold boxes, *The Final Exam* and *Hummingbird Box*. *The Final Exam* was based on a hand-engraved silver box by Bill Reid. The box was Bill's tribute to an early artist known only as the Master of the Black Field, the creator of an incredible design on a cedar bentwood box, circa 1880, that is one of the most accomplished examples of Northwest Coast design that has survived from the early period. Bill referred to his silver box as his "final exam," and after three decades of work, I wanted to follow Bill's example and take my own final exam.

For my tribute to Bill Reid and the Master of the Black Field, I used a technique that was new to Northwest Coast Indigenous art. I inlaid twenty-four-karat gold into the silver box using a technique similar to inlaying abalone shell or setting precious stones: a precise cavity in the shape of an ovoid or circle is made in the silver, and then a tiny piece of gold is cut in the same shape and set into the hole. There is no

Family of Eagles bracelet, 2019
sterling silver with oxidization, 2 × 6.5 in.

facing top right
Eagle Transforming bracelet, 2019
14K gold, 1 × 6 in.

facing bottom left
Raven Releasing the Sun
bracelet, 2019
sterling silver with oxidization, 1.5 × 6.5 in.

facing bottom right
Sun with Two Ravens bracelet, 2018
23K gold, 1.5 × 6.5 in.

glue, and the bond is permanent, as the gold is slightly larger than the hole in the silver. Through the process of making *The Final Exam* box, I was able to methodically explore the Master of the Black Field's unique approach to flat design. Later, I discovered another bentwood box by the master that was unattributed, and that piece was the inspiration for the silver-and-gold *Hummingbird Box*.

Many hours of drawing also helped me develop my understanding of design. For several years early in my career, I drew every day. Then, in 2008, when I was studying the designs painted on early bentwood boxes, I once again began sketching on a daily basis. I did that for more than two years, and there was a transformation in my jewellery engraving as I began to deeply comprehend the importance of negative space and the subtle interactions of the design elements that the early masters alluded to in their painted boxes. Applying what I learned in my studies and sketches, I was able to take my jewellery designs to another level. I still sketch regularly because Northwest Coast design is infinitely complex, with endless possibilities, and I continue to try to further my understanding of this endlessly intricate art form.

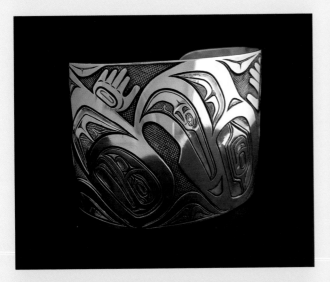

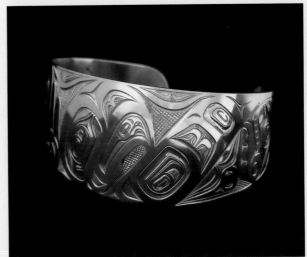

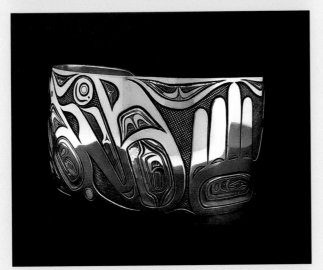

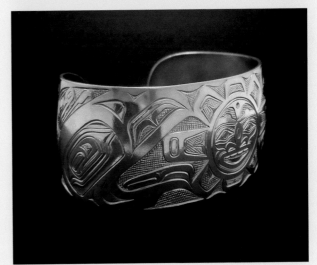

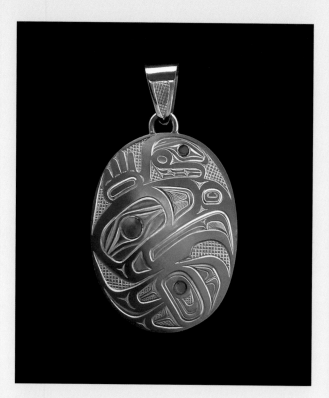

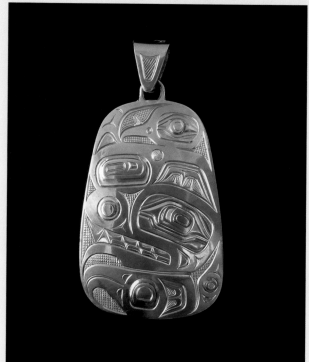

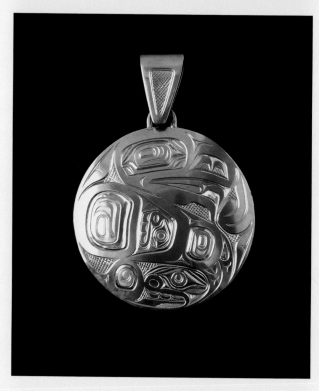

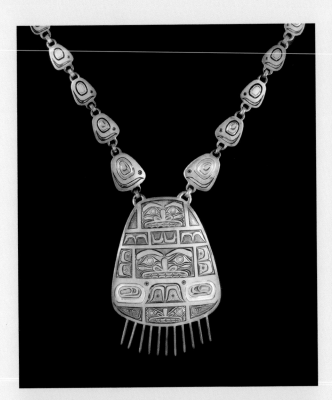

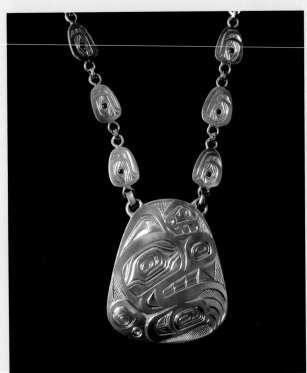

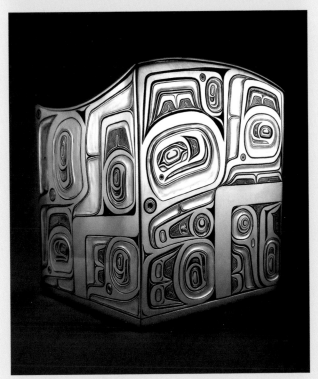

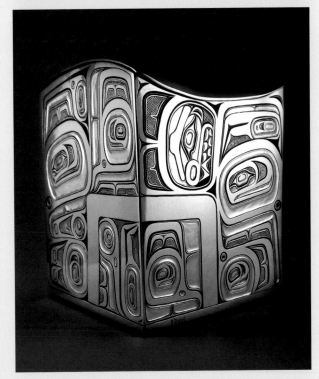

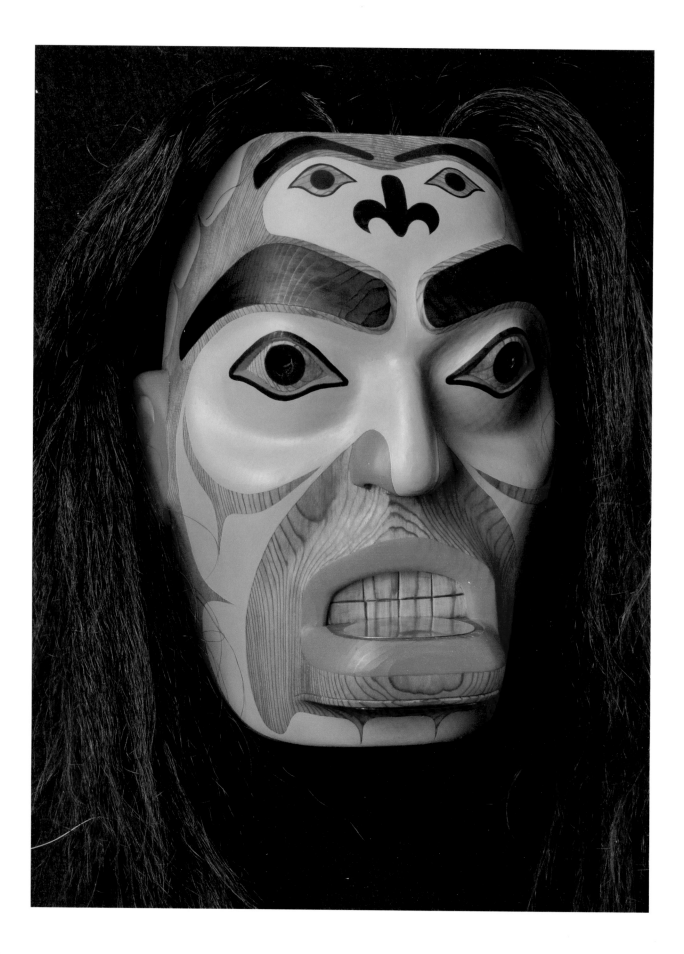

6/ HOME AGAIN
COMING FULL CIRCLE

X'ANELK AND THE WOLVES

Once, there was a young boy named X'anelk, who loved to hunt. His mother made him a warm fur blanket, and his father made him a sturdy bow and a quiver of arrows. Every morning, he left early to go hunting, and when he returned in the evening he never failed to bring home food. But his blanket became more and more ragged, as if animals were chewing on it. His father was concerned and decided to find out what was happening.

The next morning, when X'anelk went hunting, his father stealthily followed him. After a while, they came to a beach, and wolves ran up to X'anelk, excited to see him. His father was afraid for him, but X'anelk showed no fear, and soon the wolves were playing with him and pulling on his blanket. That was how the blanket was getting chewed up, his father realized. Then a wolf came to X'anelk with a grouse, which he dropped at his feet. The father crept away unseen, and later that evening X'anelk came home with a grouse, which he said was the result of his hunting.

The father told his wife of the incredible thing that he'd seen, so they decided to keep the boy in the house and have him sleep between them at night to protect him. But in the night, X'anelk got up and slipped outside, where he was met by the wolves, who took him to their village. He remained there for four days and four nights, learned their songs and

facing
Emma Martin mask, 2018
red cedar, paint, horsehair,
and copper, 20 × 11 × 9 in.

In 1921, twenty Kwakwaka'wakw people were incarcerated for practising their traditional culture during the potlatch ban (1885–1951). They served their sentences at Oakalla Prison Farm, far from their homes and families. Emma Martin moved to the city so she could visit them, bring them food, and help them during their incarceration. Upon their release, she met them and paid for their hotel accommodation, meals, new clothes, and travel expenses to their villages.

Dancing at the ceremony for the installation of my totem pole at the Vancity Credit Union, North Vancouver, 2003.

dances, and was given supernatural powers and gifts, including the Water of Life.

Over time, X'anelk became homesick and wanted to go back to his village. His village was very far away, but he rode on the back of a swift wolf, and they arrived at his village in no time. He returned to find that he had been away for many years and that his parents were nothing but bones. He sprinkled the Water of Life over their bones, and immediately flesh started to grow over them until their bodies were whole and they opened their eyes. Because of X'anelk's supernatural powers, his people prospered, and he became a respected chief like his father.

When I was a young boy, I used to gaze at my father's paintings and imagine a world of Indigenous canoes, cedar masks, and fire-lit dancers. Those images were like a dream world to me, and I couldn't be sure that they really existed. As an adult, I went on a journey that started on the plains of Alberta and took me to the farthest reaches of the United States and Central America before I found my way home. It was the Tsegame mask carved by my great-great-grandfather, which I saw in a Texas museum, that pointed me towards home. I sometimes wonder, had I not seen that mask, would I have stayed and worked as a photographer in Texas and never returned home? It is a miracle that I found my way home at all. I certainly took the most circuitous route possible.

Good fortune, fate, or my ancestors led me to rent a house in Vancouver a mere two blocks from where a Kwakwa̱ka'wakw totem pole was being carved, which made it possible for me to start carving within weeks of my return to British Columbia. I'd been away for so long that the connection to my artistic roots should have been barely a whisper by that time. But that connection was more like a drum

beat that wouldn't rest until I returned and took up a carving knife. To this day, when I smell yellow cedar I think of my grandmother and her carving studio, as though her memory and our heritage are embedded in that rich, aromatic scent.

I returned home as a writer and photographer, which afforded me the opportunity to meet some of the most knowledgeable and influential Indigenous people of my time – Chief Elijah Harper, Bill Reid, Agnes Alfred, Russell Means, and many others. Those individuals had an inestimable impact on my life. I met Indigenous men and women of great stature, who also possessed great humility. I acquired knowledge from them, and through art and photography I have endeavoured to tell their stories and share their words and teachings. Some of the people I met over the years had great talent, others great knowledge, and others great integrity. Wise and learned people shared their wisdom with me – sometimes just a few words, other times a few hours, and sometimes more. I embraced all of their teachings and I have used them in my life and my art.

The art of my ancestors and the teachings of the people I met fuelled my creativity and inspired me. It can be a temptation for an artist to find a comfortable niche and stay there, and the market often rewards that approach. But I wouldn't have been satisfied in a predictable niche, which would have left me feeling that I might have done more. The last three decades of taking photographs and making art have taught me that creativity is a process, not a destination. For example, *master carver* is a term that is often used today, but I don't believe that the old people used it or thought of our culture in that way. I consider art to be a journey, not an endpoint. I think of my art practice as a path on which I walk every day of my life. Art is a metaphor for life, and no one can be a master of life.

FOR MANY YEARS, I had my studio open to the public because customers enjoy dealing directly with the artist. But in 2012 my children were young adults, and I decided to open a family art gallery where we could work together, and they could learn about running a small business. We rented a 1,200-square-foot space a block from the waterfront in North Vancouver, and the David Neel Gallery was born. Edwin, Jamie, Ellena, and I worked hard to get the art and the space ready. It was the twenty-first-century version of my Grandma Ellen's family art business, Totem Art Studios, from the 1950s. The gallery carried my jewellery, carvings, and paintings on canvas, and, miraculously, I managed to have enough work to fill the space. My children were just starting to produce their own artwork, and I looked forward to a day when we would all show our work together. (This did happen just a few years later, in 2017, when Edwin, Ellena, and I showed our work at the Legacy Gallery in Victoria, BC, at an exhibition curated by Carolyn Butler-Palmer, titled *Ellen Neel: The First Woman Totem Pole Carver*, which included my grandmother's art and art by her grandchildren and great-grandchildren.)

Finally, everything was ready. To open the gallery, we hosted an event that included traditional foods, singing, and dancing. A former customer of my grandmother's was in attendance, and he gave me a

totem-pole pendant made by Grandma Ellen that was still in its original packaging. To have a piece of my grandmother's jewellery from fifty years ago to add to my modest collection of family art was the icing on the cake. To me, it symbolized the strength of our family heritage and the love we share for the traditional culture.

My children worked at the gallery until they started their postsecondary education, with Ellena and Edwin attending Emily Carr University. I was very busy during that period, hand engraving jewellery, making art, and managing the business. I have many wonderful memories of having a family-run gallery, but it proved to be a tall order for me to make the product and manage the business. At that time, online shopping was growing in popularity, so I changed with the times and focused on marketing my work through the internet. I'd actually had a website since the earliest days of the World Wide Web. Years ago, I remember people asking for a brochure, and when I replied that I had a website, they'd say, "Oh, and how can I see that?" Today, an artist's work can be seen on myriad social media sites and websites. My art has made a successful transition to the digital age. Even Wikipedia has a page about it. I sometimes wonder what my Grandma Ellen would think if she were to see how much things have changed. The digital era and Indian Country have found each other and enjoy a good relationship.

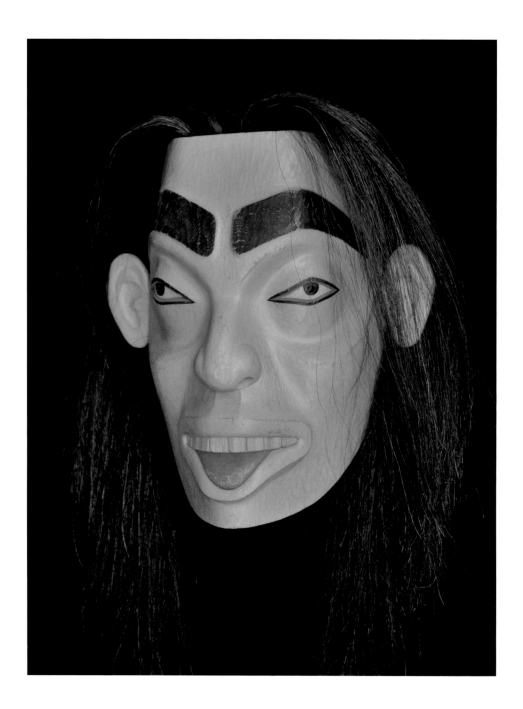

Otter Woman mask, 2016
red cedar, paint, and horsehair,
21 × 14 × 7 in.

This character from the ancient stories comes from the village of the Land Otters. She is a temptress who uses her supernatural powers to trick unwary visitors into transforming and staying to live with the otter people.

OVER THE COURSE of my career, I've also seen some of the artificial borders that have been imposed on Indigenous art come down. And I have witnessed the growing support for and appreciation of Northwest coast Indigenous art. In 1997, I was included in a group exhibition, the "Seventh Annual Native American Fine Arts Invitational," at the Heard Museum in Phoenix, Arizona, which brought my work to the attention of the organizers of the annual Indian Art Market. They invited me to show there, and I was the first and only Canadian to exhibit at the time. The Heard Museum Indian Art Market is the second largest in the United States, and the top Native American artists show their work at the two-day event. I met Native American artists from across America, and I showed there for several years. The first year, Fritz Scholder, a painter and a legend in Native American art, stopped by my booth and said he liked my work, which really made my day.

above

Residential School Mourning mask, 1993

red cedar, paint, cedar bark, horsehair, and chalkboard, 36 × 96 × 10 in.

This piece, which combines traditional and contemporary elements, symbolizes the residential school experience. The lines written on the chalkboard read "I will not speak Kwakwaka'wakw" on the left, and the same phrase repeats on the right in Kwak'wala. It was exhibited at *Out of the Darkness*, Emily Carr University, in 1993.

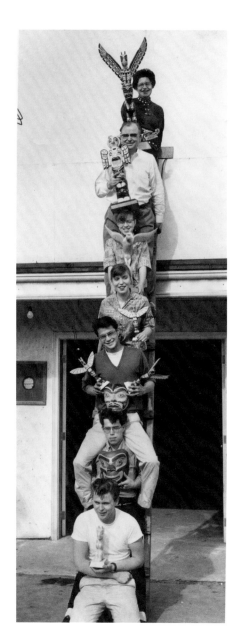

All the artists spoke about the Santa Fe Indian Market, which was organized by the Southwestern Association for Indian Arts (SWAIA) and is the largest Indian art market in America. I wanted to enter my work, but I was told the market was closed to Canadian artists. I didn't think that was right, so one year, when SWAIA held its annual general meeting in Phoenix, I attended and stated my case before the member artists. I said that virtually all Native American groups and organizations, such as powwows, recognize both Canadian and American Indigenous people equally because our ancestry predates the border between the two countries. By not allowing Canadians to participate, I continued, they were setting a precedent that went against our shared history and cultural values. The board agreed but said that they could do nothing at that time.

Not to be deterred, in advance of the next Sante Fe Indian Market, I placed a colour ad in their event magazine that included a photograph of a totem pole that I had carved and the following statement: "I wish the artists and collectors an enjoyable and prosperous Indian Art Market this year. I won't be exhibiting as Canadian Native artists aren't eligible to participate." I did attend the market that year to see my friends and collectors, and I received many positive comments for bringing the issue to the public's attention. Several years later, SWAIA changed its policy, but by that time I no longer had the time to show at art markets. In 2018, a Canadian artist from my nation, a Kwakwa̱ka̱'wakw, won first place in painting, and I was pleased to see things come full circle.

AFTER MORE THAN twenty years of working many hours every day (I rarely worked less than sixty hours a week), I paused to reflect on how I wanted to use my time in the future. I had come to appreciate that time is a valuable commodity, and I started to make time for myself

– to slow down so that I could reflect on my career and my art and to consider what in my life had value and what was illusion or simply ego. I questioned the popularly held belief that "success" means working tirelessly towards better paycheques and bigger projects, filling every hour of every day with constant activity. I think of this approach to life as being on the hamster wheel, where, to achieve success we are required to run ever faster. It seemed to me that self-reflection, or what we used to call "stopping to smell the roses," had lost its value in our society. I have found that it is beneficial to create quiet periods in my life so that I can hear the voice of intuition and inspiration.

It continues to be my nature to work in a variety of media – I refer to myself as a creative schizophrenic – and through all of these media I try to connect content with symbolism. Northwest Coast art is deeply symbolic, and I keep working to better understand its ancient meanings and import. I have tried to share that information with my children, as others have shared their knowledge and wisdom with me. This, I believe, is the foundation of Indigenous culture: to learn the traditional knowledge and pass it on to the next generation.

My father was not able to pass his knowledge on to me, but that did not prevent me from passing some of our ancient knowledge on to my children, who have inherited a love and appreciation of our traditional culture. Ultimately, I realized that finding my way home changed not only my own life but the lives of my children and grandchildren yet to come. Had I not been called home by Grandpa Charlie's mask, our Indigenous cultural heritage might have become only a distant memory to future generations of my family. But Tsegame, the Great Magician of the Red Cedar Bark, worked his magic, and I found my way home.

ACKNOWLEDGMENTS

OF THE MANY PEOPLE who have helped me in the past, a few stand out and I would like to acknowledge their assistance in helping me find my way home and for the subsequent writing of this book. Wayne Alfred and Beau Dick introduced me to Kwakwa̲ka'wakw traditional carving, which opened a door to another world. A number of people helped to reconnect with my people and our culture, most notably my aunt, Emma Tamlin, and my uncle and aunt, Chief Edwin Newman and Vera Newman, who are some of the most generous people I have known. Chief Alvin Alfred and Ethel Alfred and Chief Henry George and Edith George showed me great kindness, welcoming me to the community and sharing some of their vast traditional knowledge with me. Emma Hunt and her late husband Chief Tom Hunt were close friends with my late grandparents and Emma told me stories about my grandma Ellen that helped make up for the missing years.

I would also like to thank the staff at UBC Press who have supported my work for many years. The people who helped make this book are Darcy Cullen, Holly Keller, and Merrie-Ellen Wilcox. They helped to shape my story and images into what I hope is a story worth reading.

facing
Paddling on the Grand Canal, Venice, Italy, with gondolas in the background, in 1999. Wherever we went in the City of Masks, the *Walas-Kwis-Gila* was constantly greeted with calls of "Bellisimo!" from the locals.

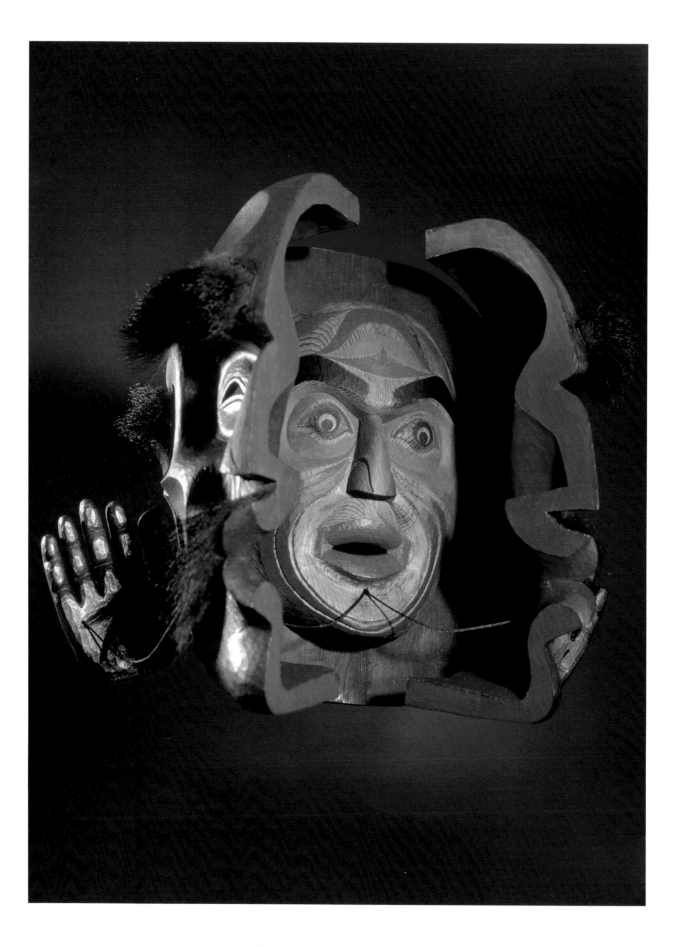

PHOTO CREDITS

Photos are by author unless otherwise attributed below.

vii *detail* Photo by Jim Ryan; material republished with the express permission of the Vancouver Sun, a division of Postmedia Network Inc.

xiv Photo by Vince Fairleigh.

2 Photo by Maurice Nahanee.

4 Photos by Karen Neel.

7 From the author's collection.

9 *left* Royal BC Museum and Archives, PN-2315.
right Photo by George Diack; material republished with the express permission of the Vancouver Sun, a division of Postmedia Network Inc.

10 Photo by Jim Ryan; Royal BC Museum and Archives, I-51780.

11 Photographer unknown.

12 Special Collections, Vancouver Public Library, VPL-62667.

14 Photo by Jim Ryan.

18 Photo by Ann Kirby.

21 Photo by Karen Neel.

24 Photo by Maurice Nahanee.

34 Division of Anthropology, American Museum of Natural History, 16-2344.

61 Photographed for the National Museum of the American Indian – Smithsonian Institution.

62 Photographed for the National Museum of the American Indian – Smithsonian Institution.

65 Photo by Betsy Peterson.

facing

Wild Woman of the Woods
transformation mask, 1999
red cedar, paint, and fur, 20 × 24 × 12 in.

In the ancient stories, the Wild Woman was of huge stature, covered with hair, and living deep in the forest. She was known to sneak into villages at night and steal food or even children, but she also had the ability to bestow supernatural gifts.

94 *bottom* Photographer unknown.
119 Photographers unknown.
120 *left* Photographer unknown.
122 Photographer unknown.
141 *left* Photographer unknown.
151 Photo by Rick Erickson.
155 *left* Photo by Maurice Nahanee.
 right Photo by Rick Erickson.
156 Photo by Rick Erickson.
167 Photographer unknown.
168 *left* Photographer unknown.
 right Photographer unknown.
172 Photo by Jim Ryan; material republished with the express permission of the Vancouver Sun, a division of Postmedia Network Inc.
173 Photo by Bill McClellin.
174 Photographer unknown.

Every effort has been made to identify, credit appropriately, and obtain publication rights for the photographs in this book. Notice of any errors or omissions in this regard will be gratefully received and correction made in subsequent editions.